CONRAD
and his world

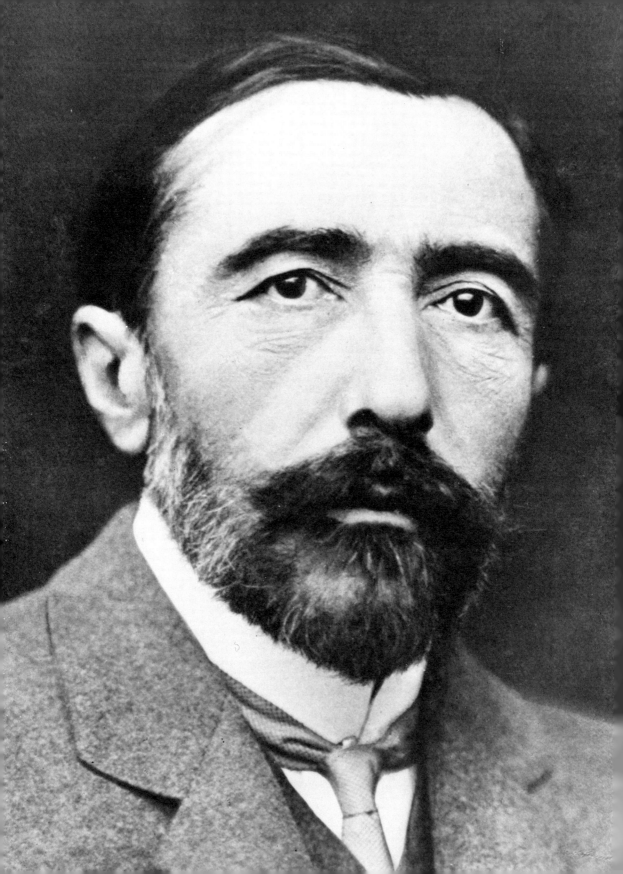

NORMAN SHERRY

CONRAD
and his world

THAMES AND HUDSON
LONDON

For Kenneth and Mary Muir

The extracts from Joseph Conrad's
works are included by permission of the
Trustees of the Joseph Conrad Estate
and J. M. Dent & Sons Limited.

Printed and bound in Great Britain by
Jarrold and Sons Ltd, Norwich

ISBN 0 500 23171 0

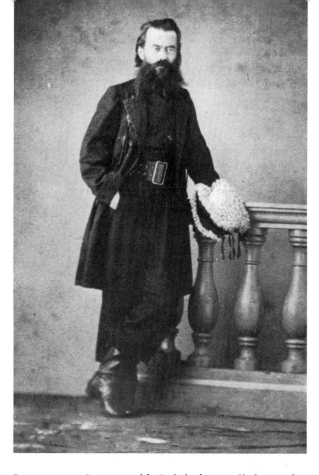

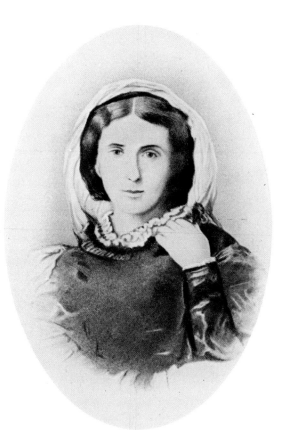

In 1863, a five-year-old Polish boy called Józef Teodor Konrad Korzeniowski, living in exile in a distant Russian province, sent a photograph of himself to his grandmother with the following inscription on the back: 'To my beloved Grandma who helped me send cakes to my poor Daddy in prison – grandson, Pole, Catholic, nobleman – 6 July 1863 – Konrad.' This inscription reflects the strange and tragic childhood of the future novelist, Joseph Conrad. Already a Pole, a Catholic and a nobleman, he might even then have added political exile, and not long afterwards orphan. Future years were to see him in the role of expatriate at the age of seventeen, sailor, gun-runner, attempted suicide, naturalized Englishman, master mariner in the British Merchant Navy, captain of a Congo river-steamer, and eventually novelist. Henry James was later to say to him, 'No one has *known* – for intellectual use – the things you know', but Conrad's response was, 'I know nothing, nothing!' Yet, it would be true to say that Conrad forgot little of his extraordinarily wide experience of life, and his memories constantly influenced his work.

His father was Apollo Nałęcz Korzeniowski, and his mother Eva Bobrowska, both members of the Polish landowning nobility in a

Apollo Korzeniowski, Conrad's father. 'A man of great sensibilities; of exalted and dreamy temperament; with a terrible gift of irony and of gloomy disposition.' (Conrad)

Eva Korzeniowska, Conrad's mother. He wrote of 'the awe of her mysterious gravity which indeed, was by no means smileless'.

country dominated by Russia. This nobility, subscribing to 'soldierly' and 'aristocratic' values, was politically active, especially in the anti-Russian insurrections of 1794 and 1830. The Korzeniowskis, counting on a successful uprising against the Russians and on social reforms, had almost all their estates confiscated because of their involvement in the insurrections. But the Bobrowskis, keeping themselves politically uninvolved and believing in a policy of appeasement, retained their estates. Thus the two families which produced Conrad were divided politically and idealistically, though both preserved the same 'aristocratic' principles. Conrad's uncle, Thaddeus Bobrowski, never failed to remind his nephew at every opportunity of the need to control the more 'romantic' Korzeniowski part of his heritage. On one occasion he wrote to Conrad:

I see with pleasure that the Nałęcz [father's family] in you has been modified under the influence of the Bobroszczaki [mother's family]. . . . This time I rejoice over the influence of my family, although I don't in the least deny that the Nałęczes have a spirit of initiative and enterprise greater than that which is in my blood.

The Bobrowskis, however, also had their unconventional members, including one who was reputed to have eaten roast dog during the Napoleonic retreat from Moscow. And in any case, Conrad's uncle undoubtedly had great hopes for his nephew and his descendants: 'From the blending of these two excellent families in your worthy person there should spring a race which by its endurance and wise enterprise will astound the whole world!'

Eva Bobrowska and Apollo Korzeniowski first met in 1847. They fell in love immediately, but Eva's father opposed their marriage, not seeing Apollo as a suitable son-in-law. 'My mother liked his company and his mode of life,' wrote Thaddeus in his memoirs, 'but could not perceive in him any qualifications for a good husband; she agreed with my father that, having no profession – for he lived at his father's home, occupying himself with nothing and owning nothing – he was an undesirable suitor in spite of his pleasant society manners.' And so it was not until 8 May 1856, five years after her father's death and following a period of ill-health for Eva, that they were able to marry. Apollo worked as an estate manager, but he was obviously not suited to such work. Thaddeus described him as 'violent in emotions . . . unpractical in his deeds, often helpless and unresourceful', and in three years Apollo, having exhausted his wife's dowry, devoted himself to politics and writing. During much of the remainder of his life he was supported by members of his wife's family.

On 3 December 1857 at Berdyczów (Ukrainian Berdichev) in Podolia, Conrad was born, their first and only child, and christened Józef Teodor Konrad Korzeniowski. Teodor and Józef were the names of his grandfathers, and Konrad seems to have come from the

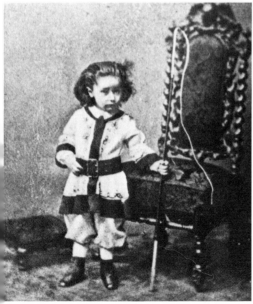

Joseph Conrad's birthplace, Derebczynka Manor, near Berdyczów, in the Ukraine.

Conrad holding a whip, photographed in Warsaw in 1862. 'Olutek sent me a fine little whip, dear Daddy, lend me a groat and buy something for Olutek in Warsaw.' This letter to his father, 4 June 1861 (when Conrad was three and a half years old), for which his hand was guided by his mother, represents the earliest surviving piece of writing by Conrad.

Patriotic Cross, a souvenir from the time of the 1861 uprising.

The Royal Castle, Warsaw, c. 1870.

hero of the famous poem *Konrad Wallenrod* by the Romantic poet and dramatist Mickiewicz.

In the spring of 1859, Apollo went to try his luck and his literary talents at Zytomierz, then the intellectual centre of the province. He had already written two satirical comedies and some poems reflecting his patriotism and social radicalism, and had translated Victor Hugo from the French; he now established a new literary fortnightly. In 1861 he moved to Warsaw, recently the scene of two massive political demonstrations which had been bloodily repressed. His wife had remained with their son in the Ukraine on her grandmother's estate: 'Konrad grows up beautifully. He has a heart of gold, and with his conscience and intellect there won't be any difficulty with you working for his future', Eva wrote to her husband. At the beginning of October 1861, she and Conrad joined Apollo in Warsaw. Their home, not surprisingly, had become a meeting-place for adherents to the cause of Polish nationalism, and Apollo was involved in underground political activity. His passionate and patriotic allegiance to Poland is expressed in this poem commemorating his son's baptism:

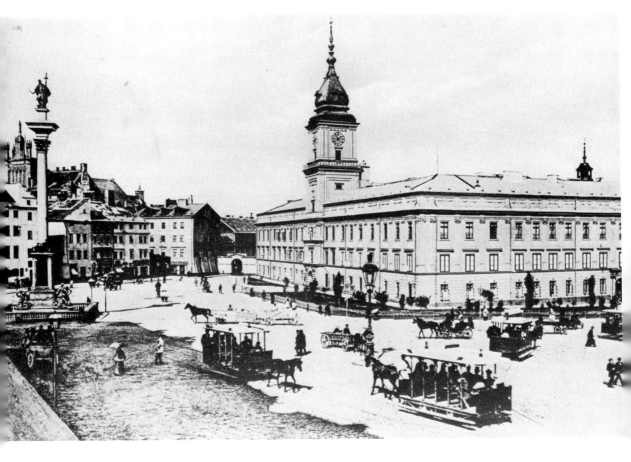

Nowy Świat Street, Warsaw. It was in the house second from the right that Apollo Korzeniowski lived with his family in 1861. After the 1861 uprising this house became the meeting place of the underground City Committee in which Apollo was involved.

My child, my son, if the enemy calls you a nobleman and a Christian – tell yourself that you are a pagan and that your nobility is rot. . . . My child, my son – tell yourself that you are without land, without love, without Fatherland, without humanity – as long as Poland, our Mother, is enslaved.

On 17 October, Apollo formed the underground City Committee. Conrad later recalled the conspiratorial meetings which he, a boy of four, had witnessed: 'its [the Committee's] first meetings were held in our Warsaw house, of which all I remember distinctly is one room, white and crimson . . . to this day I cannot get rid of the belief that all this was of enormous proportions, and that the people appearing and disappearing in that immense space were beyond the usual stature of mankind.' He remembered his mother 'dressed in the black of the national mourning worn in defiance of ferocious police regulations . . . the awe of her mysterious gravity. . . . She was young then, certainly not thirty yet.'

On 21 October Apollo was arrested when the police raided his home, and Conrad retained a memory of himself standing with his

mother in a big prison yard where he glimpsed his father's face watching them from behind a barred window. It is possible, however, that Eva was imprisoned with her husband – certainly she was co-accused at his trial and her letters to him from the country were used as evidence against him. They were sentenced to settlement in a distant province, and in May 1862, escorted by two policemen, left for exile in Vologda in northern Russia, arriving in June. Both Conrad and Eva were ill on the way. The family spent a miserable year there. Several relatives died during a new period of Russian repression, and Eva was now suffering from tuberculosis. Apollo wrote to a friend:

Vologda is a great three-verst marsh . . . everything rotting and shifting under one's feet. . . . The climate consists of two seasons of the year: a white winter and a green winter. The white winter lasts nine and a half months and the green one two and a half. We are now at the onset of the green winter: it has already been raining ceaselessly for twenty-one days. . . . The population is a nightmare: disease-ridden corpses.

The following summer, thanks to the intervention of friends, the family were allowed to move to Chernikhov, much further south,

(*Left*) Warsaw, the jail and courtyard. 'In 1862, my Father was imprisoned in the Warsaw fortress and after a few months was transported to Vologda. I accompanied my parents in their exile' (Conrad). Among other things, Apollo was accused of having caused 'the disturbances in Miodowa Street and in Wedel's cake and coffee shops'.

(*Right*) general view of Vologda, where the Conrads – father, mother and son – were in exile for a year, during which Eva's health rapidly deteriorated. 'I may allow myself the reflection that a woman, practically condemned by the doctors, and a small boy not quite six years old could not be regarded as seriously dangerous even for the largest of conceivable empires.' (Conrad)

and Eva and Conrad were permitted a visit to Thaddeus Bobrowski on his estate. After three months, in spite of Eva's illness, they were forced back into exile. In Chernikhov Apollo translated Hugo, Dickens and Shakespeare, and wrote his anti-Russian memoirs, *Poland and Muscovy*, but Eva was dying. To his friend Kazimierz Kaszweski, Apollo confided: 'nostalgia and the repeated blows falling on our families have been slowly killing my wife. . . . Our little Konrad is inevitably neglected', and on 18 April 1865, when Conrad was seven, his mother died. His father did not mask his despair:

Should I describe this place I would say that on one side it is bounded by locked doors behind which the being dearest to me breathed her last, without my being able to wipe even the death sweat from her brow, while on the other . . . I see what Dante did *not* describe. . . .

For the next three years, Conrad was to live a strange, isolated life, coloured by his father's grief and bitterness. Apollo generally referred to him as 'my poor little orphan': 'my life . . . is entirely centred upon my little Konrad . . . I shield him from the atmosphere of this place,

and he grows up as though in a monastic cell.' During this period, Conrad spent one holiday with his uncle Thaddeus, finding companionship of his own age in Thaddeus's daughter, Józefa; and later, because of illness, he was taken by his grandmother to Kiev for medical advice. This was the first of a series of mysterious illnesses that dogged Conrad's life, and at this time it was described as nervousness, gravel, migraine and perhaps epilepsy. It passed, however, when he was fourteen.

By 1867, Apollo was seriously ill with consumption and was given permission to return from exile. After some travel, father and son settled at Lvov, and here Conrad attended a preparatory school, was an avid reader, and wrote his first plays. In February 1869 they moved to Cracow. Years later, remembering his father's last months here, Conrad wrote:

I don't know what would have become of me if I had not been a reading boy. My prep finished I would have had nothing to do but sit and watch the awful stillness of the sick room flow out through the closed door and coldly enfold my scared heart . . . I looked forward to what was coming with an incredulous terror. I turned my eyes from it sometimes with success, and yet all the time I had an awful sensation of the inevitable. I had also moments of revolt which stripped off me some of my simple trust in the government of the universe.

He recalled the extraordinary occasion of his father, two weeks before his death on 23 May 1869, watching the burning of his manuscripts: 'My father sat in a deep armchair propped up with pillows. . . . His

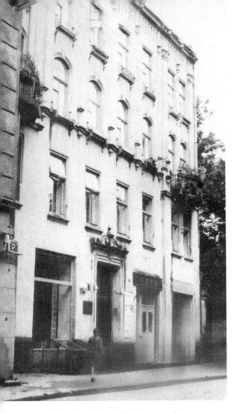

Szeroka Street II, Lvov, where Conrad lived with his father in 1868.

(*Left*) Lvov in the snow. Here father and son – 'both wandering exiles', as Apollo wrote – spent about a year.

(*Above*) view of Cracow. 'This was the time of my father's last illness. Every evening at seven, turning my back on the Florian Gate, I walked all the way to a big old house in a quiet narrow street a good distance beyond the Great Square.' (Conrad)

No. 12 Poselska Street, Cracow, where Apollo Korzeniowski died. The inscription reads: 'In this house about 1869 Conrad, son of an exile poet lived; he brought a Polish spirit to English literature and enriched it.'

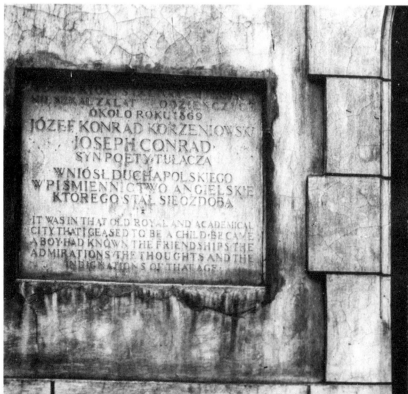

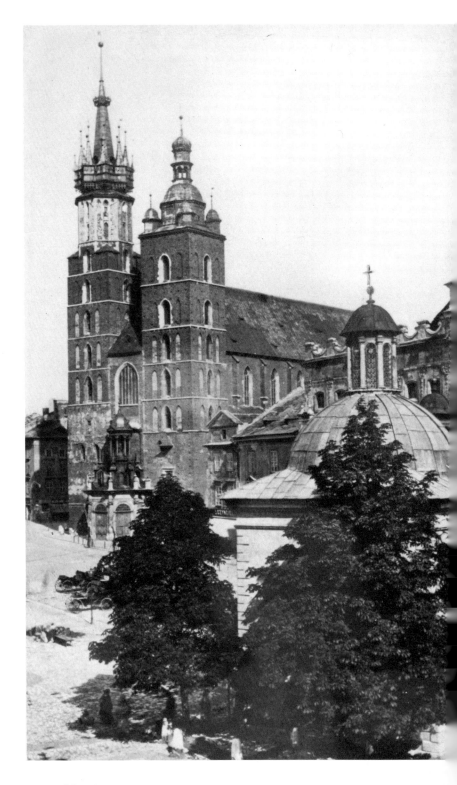

Cracow, north-east corner of St Mary's Church. 'To our right the unequal massive towers of St Mary's Church soared aloft into the ethereal radiance of the air, very black on their shaded sides, glowing with a soft phosphorescent sheen on the others.' (Conrad)

14

aspect was to me not so much that of a man desperately ill, as mortally weary – a vanquished man. That act of destruction affected me profoundly by its air of surrender. . . . But when the inevitable entered the sick room and the white door was thrown wide open, I don't think I found a single tear to shed.'

Thirty years later, Conrad described his father as having 'great sensibilities' and an 'exalted and dreamy temperament; with a terrible gift of irony and of gloomy disposition'. 'My father', he insisted, 'was no . . . revolutionary . . . in the sense of working for the subversion of any social or political scheme of existence. He was simply a patriot. . . .'

Apollo's funeral took the form of a patriotic tribute, with the eleven-year-old Conrad walking at the head of a great procession which

moved out of the narrow street . . . past the Gothic front of St Mary's under its unequal towers, towards the Florian Gate . . . I could see again the small boy of that day following a hearse; a space kept clear in which I walked alone, conscious of an enormous following, the clumsy swaying of the tall black machine, the chanting of the surpliced clergy . . . the rows of bared heads on the pavements with fixed, serious eyes. Half the population had turned out on that fine May afternoon.

According to his grandmother, Conrad was in utter, inconsolable despair.

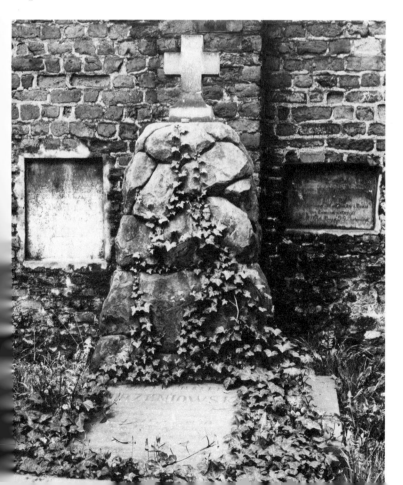

The grave of Apollo Korzeniowski in Rakowicki Cemetery, Cracow. The inscription reads: 'Apollo Nałęcz Korzeniowski, the victim of Muscovite Tyranny. Born 21 February 1820. Died 23 May 1869. To the man who loved his fatherland, worked for it, and died for it. His compatriots.'

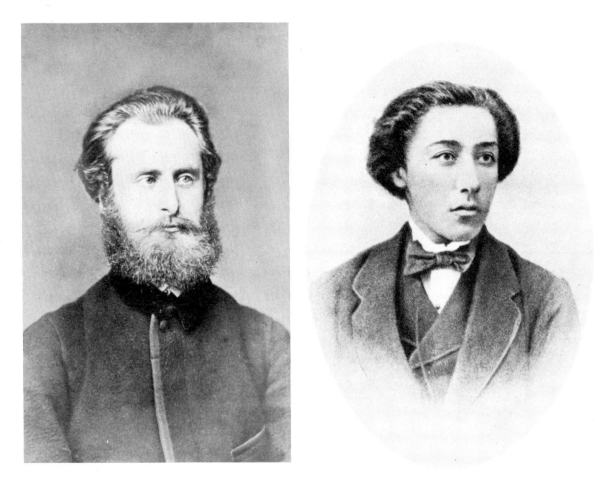

(*Left*) Thaddeus Bobrowski: 'I cannot write about Thaddeus Bobrowski, my Uncle, guardian and benefactor, without emotion. Even now, after ten years, I still feel his loss. He was a man of great character and unusual qualities of mind.' (Conrad)

Joseph Conrad in 1873. 'I tell you it was a memorable year in which I had first spoken aloud of my desire to go to sea.' (Conrad)

Conrad now came under the influence of his uncle Thaddeus, who was in every way the opposite of Apollo and who had always regarded his brother-in-law as a woolly-headed sentimentalist. He was in charge of Conrad's education and financial affairs, and was ultimately to present his nephew with a full account (now known as 'Bobrowski's Document') of what it had cost to bring him up. His influence continued to exert itself through his letters after Conrad left Poland, and his philosophy, and even phrases from his correspondence, appeared afterwards in the novelist's work. He was the type of benevolent guardian figure that Conrad dealt with in the character of Stein in *Lord Jim* and Captain Lingard in the Bornean novels.

Conrad was first placed in a boarding-house in Cracow; and a medical student, Adam Marek Pulman, was chosen to be his private tutor. His grandmother stayed in Cracow from 1870 to 1873 to take care of the boy, but in September 1873 he was sent to a boarding-house in Lvov run by a distant relative, Antoni Syroczyński. It seems likely that Conrad was at odds with his environment at this time, and

16

was felt to be getting out of hand. A relative remembered him at school as being

intellectually well developed, he hated the rigours of school, which tired and bored him; he used to say that he had a great talent and would become a great writer. This, coupled with a sarcastic smile on his face and frequent critical remarks on every-thing, provoked surprise in his teachers and ridicule in his colleagues.

Apparently, while he was at Lvov, Conrad fell in love, either with Tekla Syroczyńska or with Janina Taube, the sister of friends of his. He said later that Antonia Avellanos in *Nostromo* was modelled on his first love, who was 'the standard-bearer of a faith to which we all were born but which she alone knew how to hold aloft with an unflinching hope!'

Conrad had told his uncle Thaddeus in 1872 that he wished to go to sea. Thaddeus's shock 'could not have been greater if I had announced the intention of entering a Carthusian monastery', Conrad recalled. His ambition caused 'a wave of scandalized astonishment' in Cracow. 'People wondered what Mr T. B. would do now with his worrying nephew and . . . hoped kindly that he would make short work of my nonsense.' A trip to Switzerland with his tutor in the summer of 1873, and the removal to the boarding-house seem to have been attempts to influence him, but Conrad was not to be shaken. In 1874, Thaddeus agreed to send him off 'to the Merchant Marine which you had been continually badgering me about for two years', as he recorded in his 'Document'.

Behind this desire to leave Poland and to join the merchant navy was the inspiration of Conrad's reading of adventure and travel literature and his interest in geography, but both he and Thaddeus must have been influenced by the fact that, as the son of a political prisoner, Conrad risked conscription in the Russian Army for pos-sibly as many as twenty-five years. Certainly Thaddeus had tried in vain to secure him Austrian citizenship, but just as certainly the question why Conrad left his homeland cannot be fully answered. Years later, in *A Personal Record*, Conrad raised that mysterious question: 'Why should I . . . undertake the pursuit of fantastic meals of salt junk and hard tack upon the wide seas? . . . The part of the in-explicable should be allowed for in appraising the conduct of men in a world where no explanation is final.' In any case, in October 1874, Conrad left Poland for Marseilles, with introductions arranged and a reasonable amount of money – 2,000 francs a year in monthly instal-ments. Behind him already was more tragic experience than is given to many men in a lifetime: he was moved by the unlikely impulse, for a native of a land-locked country, to become a seaman; and, not yet seventeen, he was stepping alone into a new existence. This action, in its essentials, was to become a characteristic one of Conrad at intervals during his life.

Cracow. No. 43 Florian Street where, in 1869 and 1870, after his father's death, Conrad lived in a pension. 'At eight o'clock of every morning that God made, sleet or shine, I walked up Florian Street.' (Conrad)

(*Overleaf*) the Old Port of Marseilles. It was here that Conrad began his career as a seaman in 1874 and had those adventures which were to form the basis of *The Arrow of Gold*.

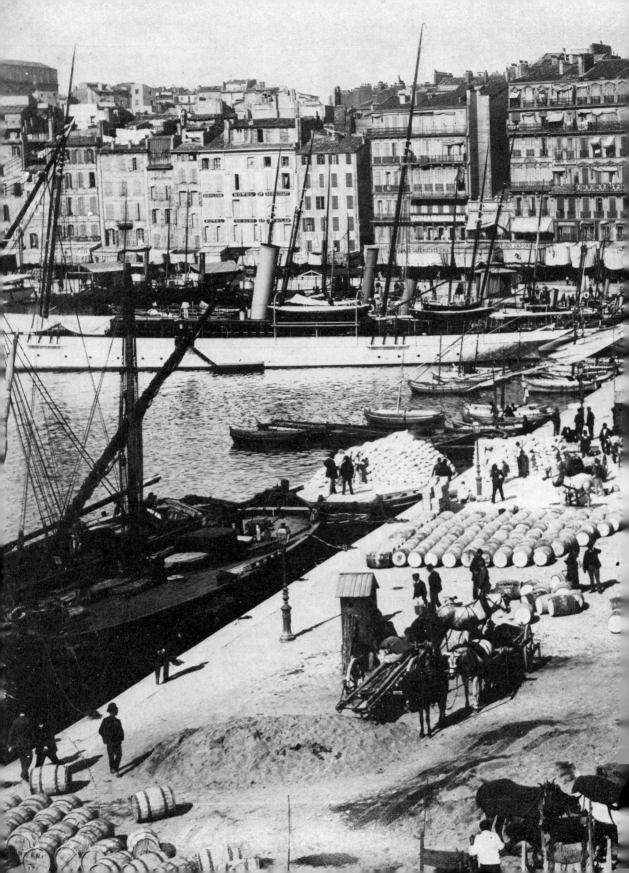

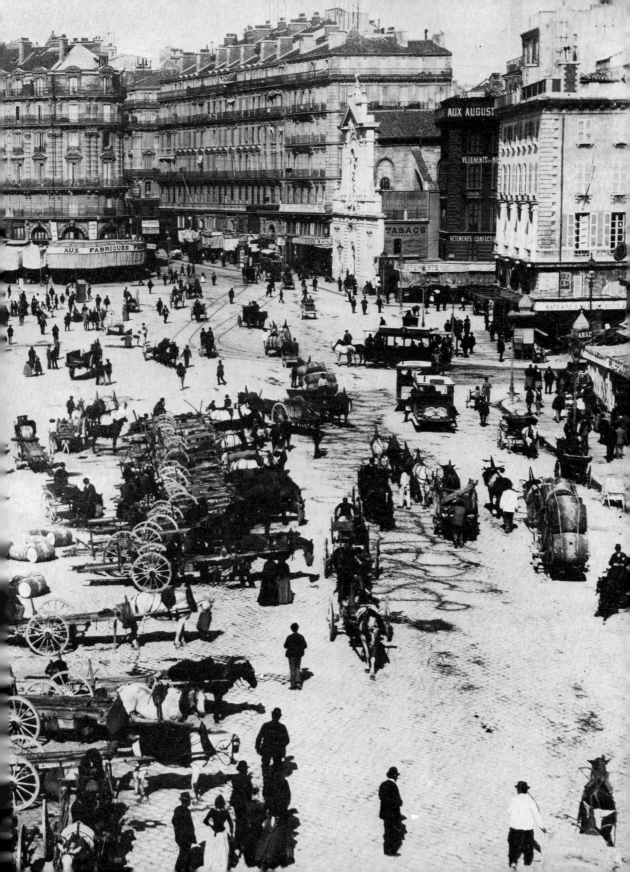

C. Delestang's certificate of discharge of Conrad's service on the *Mont Blanc*, Marseilles, 26 April 1880.

'I was still asleep in my room in a modest hotel near the quays of the old port, after the fatigues of the journey via Vienna, Zurich, Lyons when he burst in flinging the shutters open to the sun of Provence and chiding me boisterously for lying abed.' This, according to Conrad, was his first meeting with Baptistin Solary, one of the men appointed to keep an eye on him in Marseilles.

Conrad was to spend four years in France and, at least initially, it must have seemed to the young man of seventeen that all his desires were being fulfilled. As 'le petit ami de Baptistin', he was made a guest of the Corporation of Pilots, and had the freedom of their boats and homes night and day: 'I have been invited to sit in more than one tall, dark house of the old town at their hospitable board, had the *bouillabaisse* ladled out into a thick plate by their high-voiced, broad-browed wives. . . .' Apart from his connections in the old port, Conrad

probably had introductions to M. Delestang, the ship-owner in whose ships he was to sail. He described M. Delestang as 'a frozen-up, mummified Royalist' and his wife as 'an imperious, handsome lady' who reminded him of Lady Dedlock in Dickens's *Bleak House*. As a Royalist, M. Delestang was deeply involved in the attempts of Don Carlos de Bourbon to obtain the throne of Spain. Apparently also Conrad took part in the café and bohemian society of the port; at that time Marseilles had a lively intellectual life. According to his biographer, G. Jean-Aubry, Conrad retained a special affection for Marseilles always, and especially for the Café Bodoul, meeting-place for the Royalists.

Most important of all, Conrad now began his career as a seaman. Two months after his arrival in Marseilles, he made his first voyage – as a passenger – to Martinique in the *Mont Blanc*, and on her next visit to the West Indies on 25 June 1875 he was listed as an apprentice.

He returned to Marseilles in December 1875 and spent the following six months there. He would seem at this time to have devoted himself to enjoying life in the port, and he certainly spent a good deal of money. In his 'Document', Thaddeus set down an account of Conrad's extravagances:

I learned . . . that you had drawn from the Bank in one sum your allowance for the eight months from January till October of that year, and having lent it (or possibly

The Promenade du Prado, Marseilles. 'Madame Delestang, an imperious handsome lady in a statuesque style, would carry me off now and then on the front seat of her carriage to the Prado, at the hour of fashionable airing.' (Conrad)

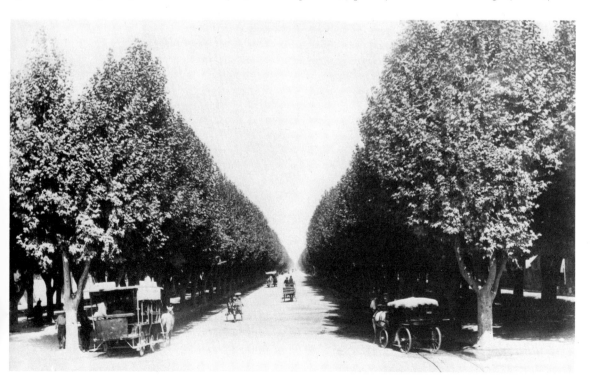

squandered it) you are in need. Subsequently in May, you wrote to me apologizing but not offering any clear explanation. At last on 21 May you sent a telegram requesting an order for 700 fr. which was paid out to you on 2 July: again in answer to another telegraphic request I ordered 400 fr. to be paid out to you, and on departing from Marseilles you wrote asking me to pay 165 fr. to a friend of yours – Mr Bonnard, who had lent you this sum and so I did.

Conrad's money difficulties, which plagued him all his life, had begun.

On 8 July 1876, he sailed again to the West Indies, this time as a steward on the *Saint-Antoine* – a memorable voyage for him, for the first mate was a certain Corsican called Dominic Cervoni, a man of forty-two who was to impress Conrad greatly at that time and to figure, later on, in *The Mirror of the Sea* and *Nostromo*. Conrad writes of him:

His thick black moustaches [were] curled every morning with hot tongs by the barber at the corner of the quay. . . . For want of more exalted adversaries Dominic turned his audacity fertile in impious stratagems against the powers of the earth, as represented by the institution of Custom-houses and every mortal belonging thereto – scribes, officers, and guardacostas. . . . He was the very man for us, this modern and unlawful wanderer with his own legend of loves, dangers, and bloodshed.

Cervoni was the type of heroic wanderer and adventurer, 'the embodiment of fidelity, resource and courage', that Conrad so admired.

On board was another eighteen-year-old, Cesar Cervoni (not related to Dominic), whose son wrote to me recently that his father knew Conrad as a 'Polish nobleman' and recalled his arrival on board the *Saint-Antoine*:

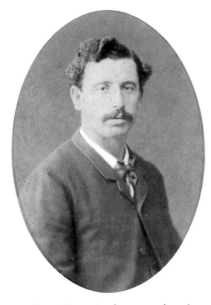

Cesar Cervoni, who was on board the *Saint-Antoine* with Conrad.

One day . . . my father saw a slim and very distinguished man arrive. . . . He went to the forecastle to greet him and the captain invited him to follow them to his cabin. . . . After having tidied up the small cabin in which this passenger was going to stay, my father went out for news and met the Captain who told him in *patois* to take care of the man and to spare him too many contacts with the other members of the crew.

We know nothing of Conrad's experiences on this voyage, though he hinted at various nefarious activities, probably some gun-running with Cervoni. Certainly he received a letter of strong rebuke from his uncle while he was in the West Indies:

You always, my dear boy, made me impatient – and still make me impatient by your disorder and the easy way you take things – in which you remind me of the Korzeniowski family – spoiling and wasting everything – and not my Sister, your Mother, who was careful about everything. Last year you lost a trunk full of things – and tell me – what else had you to remember and look after if not yourself and your things? Do you need a nanny? . . . Now again, you have lost a family photograph and some Polish books – and you ask me to replace them! Why? So that you should take the first opportunity of losing them again!

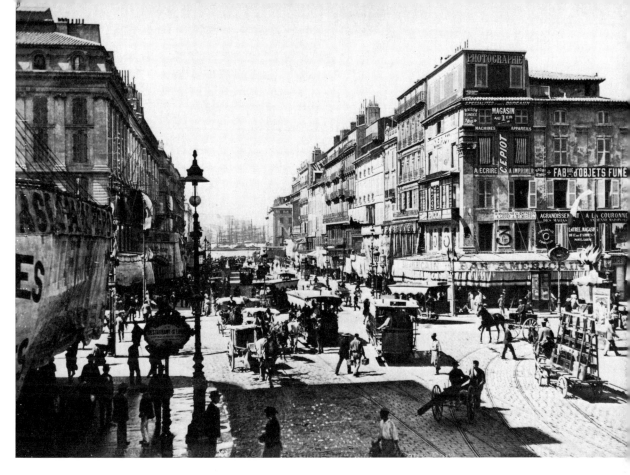

And back in Marseilles in February 1877, he found another detailed account of his extravagances waiting for him: 'in short, during two years you have by your transgressions used up your *maintenance for the whole third year!!!*'

The period from March 1877 to February 1878 was to form the climax of Conrad's experience in Marseilles. His own version of what happened then, which comes partly from suggestions in his writings based on that period, was for many years accepted as the truth. That it was not entirely accurate is less significant when one learns that the truth was equally as dramatic as the fiction.

He was prevented from sailing again in the *Saint-Antoine* in March 1877 because of an anal abscess, and on the excuse that he was later to make a world voyage in this ship, Conrad obtained another 3,000 francs from Thaddeus. He had quarrelled with M. Delestang, and now considered transferring to the British Merchant Navy, or seeking help from the Japanese Consul in joining the Japanese Navy. From the autumn of 1877 until February 1878, Thaddeus concluded that Conrad was voyaging in the *Saint-Antoine*. Conrad's *The Mirror of the Sea* and *The Arrow of Gold* later

View of the Rue Cannebière and the Old Port, Marseilles. 'Certain streets have an atmosphere of their own, a sort of universal fame. . . . One of such streets is the Cannebière, and the jest: "If Paris had a Cannebière it would be a little Marseilles" is the jocular expression of municipal pride. I, too, have been under the spell. For me it has been a street leading into the unknown.' (Conrad)

suggested that he was in fact involved in a highly dangerous venture with a smuggling syndicate organized by a woman called Rita de Lastaola.

Conrad, Dominic Cervoni and Cesar Cervoni were supposedly smuggling arms into Spain for the Carlist cause on the *Tremolino*. The ship was ultimately sunk to prevent capture. Later, Conrad told his wife that 'he and the other smugglers had hidden for days in a low posada, in an underground cellar that was more like a cavern, till the authorities had given up the search.' Conrad, supposedly in love with Rita, many years later wrote to Sir Sidney Colvin that those '42-year-old episodes' still brought 'a slight tightness of the chest'. *The Arrow of Gold* suggests that he fought a duel over Doña Rita and was wounded.

If Conrad was engaged in smuggling arms for the Carlists with Dominic Cervoni, it could only have been after 14 October 1877 since until then Cervoni was serving as second officer on the *Saint-Antoine*. Don Carlos had, however, abandoned his attempt on the Spanish throne in February 1876, and the Spanish Government declared an amnesty for Carlist exiles in France. It is true, however, that arms were being smuggled into the Basque provinces for some time afterwards, and Conrad might have been involved.

What would seem to be the truth – though not the whole truth – about this period of his life is put forward in a letter from his uncle Thaddeus to a friend which was not discovered until 1937. According to this, in February 1878, Thaddeus received the following telegram from Marseilles: 'Conrad blessé envoyez argent – arrivez' (Conrad wounded send money – come). Arriving in Marseilles, he found his nephew recovering from an attempt at suicide, not from a duelling wound.

Apparently Conrad had been prevented from joining the *Saint-Antoine* because of an irregularity in his papers:

. . . the Bureau de l'Inscription forbade him to go on the grounds of his being a 21-year-old alien. . . . Then it was discovered that he had never had a permit from his consul – the ex-Inspector of the Port of Marseilles was summoned who in the register had acknowledged the existence of such a permit – he was severely reprimanded and nearly lost his job. . . . The whole affair became far too widely known and . . . Konrad was forced to stay behind with no hope of serving on French vessels.

He then used his 3,000 francs to take part in a smuggling escapade for gain, lost his money and was left penniless and in debt. He borrowed 800 francs and went to Villefranche to join the American naval service as an American squadron was anchored there. Failing in this, he tried his luck at Monte Carlo and lost his 800 francs. He returned to Marseilles, invited the man who had loaned him the money to tea, but before he arrived made an attempt to shoot himself:

'The bullet goes *durch und durch* near the heart without damaging any important organ.'

Taking stock of the situation in Marseilles, Thaddeus recorded that he paid out another 3,000 francs to clear Conrad's debts and noted that his nephew did not drink, or gamble; that his manners were good; that he was popular with the seamen and captains; and that he seemed a skilled sailor. 'My study of the Individual has convinced me that he is not a bad boy, only one who is extremely sensitive, conceited, reserved, and in addition excitable. In short I found in him all the defects of the Nałęcz family.' Later, his uncle, who never feared treading on corns, was to tell Conrad: 'You were idling for nearly a whole year – you fell into debt, you deliberately shot yourself.' It was clearly time to leave Marseilles, and Conrad made a second leap into the unknown.

Monte Carlo gaming rooms, 1890. After losing 800 francs here, in February 1878, Conrad attempted suicide.

Lowestoft, *c.* 1890. Conrad arrived here on 18 June 1878, speaking little English and knowing no one.

He loved the profession he had chosen and refused to give it up, and so it was agreed that 'he should join the English Merchant Marine where there are no such formalities as in France'. In Conrad's own words, the decision had been formulated 'in the Polish language' and he 'did not know six words of English', yet, four years after leaving Poland, he abandoned France, sailing for England in the British ship *Mavis*, a coal freighter bound first for Constantinople and then for Lowestoft, where she arrived on 18 June 1878.

Ford Madox Ford, Conrad's later friend and collaborator, helps to place the significance at that time of what Thaddeus called 'the misty shores of hospitable Albion':

During the last century if you went down to Tilbury Dock you would see families of Jewish-Poland emigrants landing. As soon as they landed they fell on their hands and knees and kissed the soil of the land of Freedom . . . England . . . an immense power standing for liberty and hospitality for refugees; vigilant over a pax Britannica that embraced the world . . . Conrad was a Pole of the last century [and he] could ask nothing better.

But within a few months, in July 1878, Thaddeus was again writing in anger and exasperation to Conrad:

Really, you have exceeded the limits of stupidity permitted to your age! and you pass beyond the limits of my patience! What possible advice can I – so far away – give, not knowing the conditions of your profession in general and the local conditions in particular? When you decided on this unfortunate profession, I told you: I don't want and am not going to chase after you to the ends of the world – for I do not intend nor do I wish to spoil all my life because of the fantasies of a hobbledehoy . . . you must think for yourself and fend for yourself, for you have chosen a career which keeps you far from your natural advisers. You wanted it – you did it – you voluntarily chose it. Submit to the results of your decision.

Conrad's misdemeanour on this occasion lay in quarrelling with the captain of the *Mavis* on the return journey from Constantinople and leaving the ship when she reached Lowestoft. He then went to London and spent most of his money. His uncle was exasperated: 'you write to me as if to some school-chum "send me 500 francs which you can deduct from the allowance"; – from which allowance, pray? – from the one you give yourself?' This rejection from the usual source of help no doubt came as a shock to Conrad, and in a very short time he found another ship, the *Skimmer of the Seas*, a coaster running between Lowestoft and Newcastle. He does not seem to have applied so readily to his uncle for money again. He was beginning his life as a seaman in earnest, and beginning it right at the bottom. It must have required a great deal of determination for a young man of Conrad's background to lead the life of an ordinary seaman in those days.

Newcastle upon Tyne. Conrad made six voyages in the *Skimmer of the Seas* from Lowestoft to Newcastle in 1878.

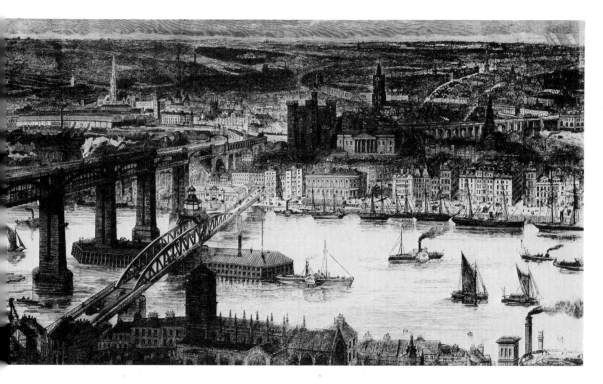

Conrad aged twenty-eight, midway in his career as a merchant seaman.

From the year 1878 when he was twenty to the year 1894 when he was thirty-six, Joseph Conrad was a restless, adventurous, merchant seaman, with the emphasis upon the restlessness. He began the period as a young foreigner with very little English, with a dreamy expression and a hint of determination in his eyes, if his portrait of 1873 is an accurate one. He was M. George of *The Arrow of Gold*, with impeccable manners and a capacity for going through money quickly. He was Decoud of *Nostromo*, cosmopolitan and cynical. He was still Józef Teodor Konrad Korzeniowski. He ended the period in 1896, as photographs show, as a bearded sea captain, with a stern glance and a lined face, a man of vast experience and broken health, with a strong foreign accent, with no great success in his present career, but as Joseph Conrad the novelist, who had published in England his first novel, *Almayer's Folly*.

Writing later of his earliest experiences in England he said:

... the North Sea was my finishing school of seamanship before I launched myself on the wider oceans. ... My class-room was the region of the English East Coast which, in the year of Peace with Honour, had long forgotten the war episodes belonging to its maritime history. ... My teachers had been the sailors of the Norfolk shore; coast men, with steady eyes, mighty limbs, and gentle voice ... each built as though to last for ever, and coloured like a Christmas card. Tan and pink – gold hair and blue eyes – with that Northern straight-away-there look!

He stayed with the *Skimmer of the Seas* until September 1878, and then prepared to launch himself on wider oceans by going to London

in search of another berth: 'I had come up from Lowestoft . . . to "sign on" for an Antipodean voyage in a deep-water ship. . . . No explorer could have been more lonely. I did not know a single soul of all these millions that all around me peopled the mysterious distances of the streets.'

His search was successful: on 12 October 1878 he embarked as an ordinary seaman on a wool-clipper, the *Duke of Sutherland*, bound for Australia. He later recalled listening for hours to a 'most pertina-cious pedlar' crying 'Hot saveloys' in George Street, Sydney, 'where the cheap eating-houses (sixpence a meal) were kept by Chinamen (Sun-kum-on's was not bad)', while 'sitting on the rail of the old *Duke of S—* (she's dead, poor thing! a violent death on the coast of New Zealand)'.

George Street, Sydney, *c*. 1880.

The *Duke of Sutherland*, possibly in Sydney harbour. It was one of the wool-clippers that 'knew the road to the Antipodes better than their own skippers'. (Conrad)

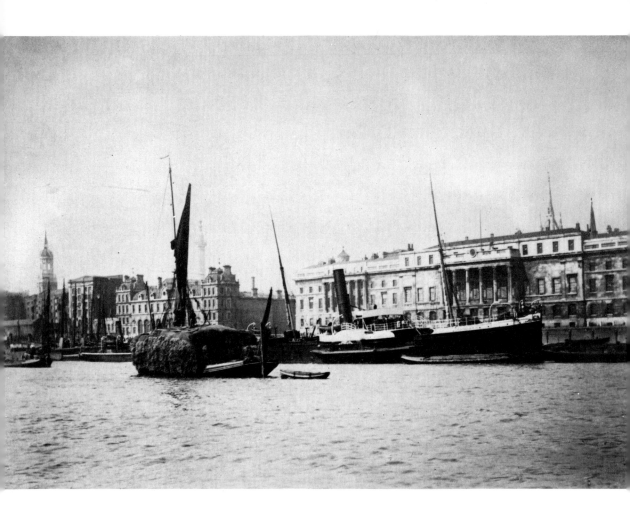

The Pool of London, *c.* 1885. 'That was in the days when, in the part called the Pool, just below London Bridge, the vessels moored stem and stern in the very strength of the tide formed one solid mass like an island covered with a forest of gaunt, leaf less trees.' (Conrad)

Conrad moved steadily after this through the various stages of seamanship, obtaining his second mate's ticket in 1880; his first mate's in December 1884; and his master's on November 1886. 'I have been face to face at various times with all the examiners of the Port of London, in my generation. . . . Three of them were examiners in seamanship, and it was my fate to be delivered into the hands of each of them at proper intervals of sea service.' He came out of the first after three hours of questioning and 'began to walk on air'. His uncle Thaddeus was equally delighted, but also sobering: 'Firstly, Dear Sir, you have proved to our country and your own people that you have not eaten your bread in the world for four years in vain; secondly, that you have succeeded in overcoming the difficulties that arise from the language itself, and from your difficult position as a foreigner without any patronage to support you. . . . Now we need work and endurance, endurance and work. . . .' And when Conrad obtained his Master's certificate: 'Long live the "Ordin.

30

By The Lords of the Committee of Privy
Council for Trade.

Certificate of Competency
as
MASTER.

To Conrad Korzeniowski

Whereas it has been reported to us that you have been found duly
qualified to fulfil the duties of Master in the Merchant Service, we
do hereby, in pursuance of the Merchant Shipping Act, 1854, grant you this
Certificate of Competency.

By Order of the Board of Trade,
this 11th day of November 1886

Countersigned,
Registrar General.

One of the
Assist. Secretaries
to the
Board of Trade.

Registered at the Office of the Registrar General of Shipping and Seamen

Master in the British Merchant Service"!! May he live long! May he be healthy and may every success attend him in every enterprise both on sea and on land!' Thaddeus never ceased to urge one further step towards security on Conrad: 'I do not wish you to visit Russia until you are naturalized as an English subject'; 'It is impossible to be a "Vogel frey" [free bird] all your life. One has to acquire some civil status'; 'I must admit that I should prefer to see your face a little later, and as that of a free citizen of a free country, rather than earlier and still as that of a citizen of the world!' In 1886 Conrad was able to tell his uncle that he was now a British subject. And his uncle responded, 'I embrace my Britisher and nephew wholeheartedly.'

But these successes were accompanied by failures and discontents and restlessness, which, when reported to Thaddeus, aroused in him puzzlement, anger and anxiety at different times. Conrad, for example, does not appear to have stayed long with any ship, frequently because he quarrelled with the captain. This happened in the case of

Conrad's master's certificate, 1886. 'I have been face to face at various times with all the examiners of the Port of London, in my generation.' (Conrad)

31

the *Mavis* in 1878; it happened with the *Europa*, a steamship in which he sailed in 1879; with the *Loch Etive*, another wool clipper in which he sailed in 1880 ('neither the tone, nor the manner, nor yet the drift of Captain S—'s remarks addressed to myself did ever, by the most strained interpretation, imply a favourable opinion of my abilities'); it happened with the *Riversdale* in 1883. Thaddeus wrote on one occasion of the master of the *Europa*:

> Your discomposure because of that madman Captain Munro worries me not less than it does you, although I don't understand English logic, since if the Captain is a madman his certificate and commission should be withdrawn. Until he is judicially proclaimed mad his certificate must remain valid. Well, we won't change the English, so having to deal with them, we must adapt ourselves.

A further sign of Conrad's restlessness lay in his intermittent plans for making money in some other way – by becoming secretary to a Canadian businessman, by investing in a business venture, by going in for whaling. Thaddeus always scotched such ideas: 'You would not be a Nałęcz, dear boy, if you were steady in your enterprises and if you didn't chase after ever new projects'; 'Since you are a Nałęcz, beware of risky speculations based only on hope; for your grandfather squandered all his property speculating, and your Uncle . . . got into debt . . . and died heavily in debt.'

It was after leaving the *Europa* that Conrad met two men whose friendship for him was to last many years. In January 1880, at the offices of a shipping agent, he was introduced to G. F. W. Hope, a company director who had once sailed, as had Conrad, in the *Duke of Sutherland*. The two men went into the London Tavern for lunch, and Hope recalls Conrad's 'very broken English'. Hope saw Conrad afterwards whenever he returned from a voyage, and heard of his experiences and plans. At the same time, January 1880,

The wool-clipper *Loch Etive* at Melbourne, Australia. Conrad sailed in her in 1880.

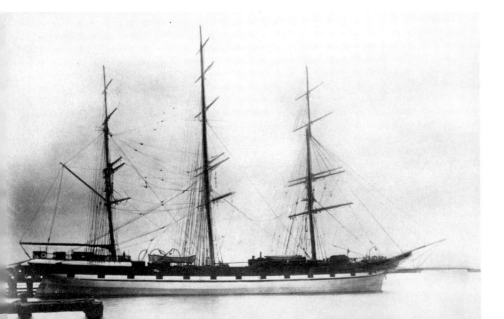

A. P. Krieger and his wife. Krieger was one of Conrad's earliest English friends.

Conrad had lodgings at Tollington Park where A. P. Krieger also lodged, and when Krieger married in 1881 and went to live at Stoke Newington it is likely that Conrad lodged with him between voyages until about 1886. Krieger had a number of occupations, being at one time connected with the firm of shipping agents, Barr, Moering & Co. Hope and Krieger acted as Conrad's sureties when he applied for naturalization.

After sailing in the wool-clipper *Loch Etive* to Sydney and returning in her via the Cape Horn route in April 1881, Conrad found a

The Circular Quay, Sydney. 'From the heart of the fair city, down the vista of important streets, could be seen the wool-clippers lying at the Circular Quay – no walled prison-house of a dock that, but the integral part of one of the finest, most beautiful, vast and safe bays the sun ever shone upon.' (Conrad)

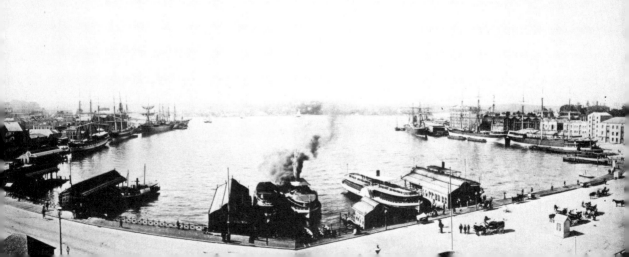

PARTICULARS OF ENGAGEMENT.

Reference	SIGNATURES OF CREW.	Year of Birth.	Town or County where born.	If in the Reserve, No. of Commission or R V 2.	Ship in which he last served, and Year of Discharge therefrom. State Name, and Official No. or Port she belonged to.	Year.	Date and Place of joining present Ship. Date.	Place.	In what Capacity engaged, and if Master, Mate, or Engineer, No. of his Certificate.	Time at which he is to be on board.
	1	2	3	4	5	6	7	8	9	10
1	E Beard Master to sign first.	57	Colchester		Continue		1881		89209 Master 12632	
2	H Mahon	50	Dublin		Carlota London	1881	19 Sept	London	Mate	21 Sept
3	Conrad Korzeniowski	24	Zitomir Poland		Loch Etif Glasgow		19 d.º	d.º	08361 2.º Mate	8 am d.º
4	Andres Thronsen	40	Frederickstad Norway		Norwegian Vessel		19 d.º	d.º	Carpenter & Seaman	d.º
5	Henry Stockbridge	63	P.E. Island		Runnymede London		19 d.º	d.º	Steward & Cook	d.º
6	Frank X Berry his mark	30	Jersey		X Seamaxie Shields		19 d.º	d.º	A.B.	d.º
7	John Driscoll	25	London		Torrington London		19 d.º	d.º	A.B.	d.º
8	W.m Dunkason	28	Beaulieu Hampshire		Thames d.º		19 d.º	d.º	A.B.	d.º
9	J Jaamsen	43	Drammen		Clyde d.º		19 d.º	d.º	A.B.	d.º

Crew list of the *Palestine*. Conrad's signature is third from the top.

berth as second mate on the fated barque *Palestine*, bound for Bangkok. It was a momentous voyage in many ways, described later by Conrad in his story *Youth*. The *Palestine* was old and not up to sailing to the Far East. It took her sixteen days to get from London to the Tyne because of a gale; on coming out of the Tyne she rammed a steamer which caused further delay. In December, after heavy gales, she had to put back into Falmouth. Then followed a nine months' delay; the cargo of coal was discharged and stored under cover; the vessel was repaired in dock; there were numerous changes of crew. Conrad's uncle had much to say about this ship and her owner:

Certainly your success depends to some extent on chance or luck, but your judgment plays an important part as well . . . cool judgment seems to have deserted you when you accepted such a wretched ship as the *Palestine*. . . . Danger is certainly part of a sailor's life, but the profession itself should not prevent you from having a sensible attachment to life nor from taking sensible steps to preserve it. Both your Captain Beard and you appear to me like desperate men who look for knocks and wounds, while your ship-owner is a rascal who risks the lives of ten good men for the sake of a blackguardly profit.

At last, the *Palestine* cleared for Bangkok. She was 'all rust, dust, grime', 'heavy with age' and she 'wallowed on the Atlantic like an old candle-box'. But trouble did not come to the vessel until she was east of the Bangka Strait when her cargo of coal caught fire: '. . . on the 14th the hatches being on but not battened down, the decks blew up fore and aft as far as the poop. . . . About 11 p.m. the vessel was a mass of fire, and all hands got into the boats, three in number. . . . The boats remained by the vessel until 8.30 a.m. on the 15th. She was still above the water, but inside appeared a mass of fire.' [Report of the Court of Inquiry into the loss of the *Palestine*.]

In *Youth* Conrad describes the death of the 'old hooker': 'As we pulled across her stern a slim dart of fire shot out viciously at us, and suddenly she went down, head first, in a great hiss of steam.'

That amazing voyage ended with thirteen hours in open boats before the crew landed at Muntok on the island of Bangka, off the coast of Sumatra. This was Conrad's first meeting with the East and its people, with the environment that was to inaugurate the change from seaman to novelist:

I see it always from a small boat [he wrote], a high outline of mountains, blue and afar in the morning . . . I have the feel of the oar in my hand, the vision of a scorching blue sea in my eyes. . . . We drag at the oars with aching arms, and suddenly a puff of wind . . . comes out of the still night – the first sign of the East on my face. . . . And then I saw the men of the East – they were looking at me. The whole length of the jetty was full of people. I saw brown, bronze, yellow faces, the black eyes, the glitter, the colour of an Eastern crowd. And all these beings stared without a murmur, without a sigh, without a movement. They stared down at the boats, at the sleeping men who at night had come to them from the sea.

Muntok, from Bangka Strait – Conrad's first view of the East, March 1883. Much later Conrad wrote: 'Muntok is a damned hole without any beach and without any glamour.'

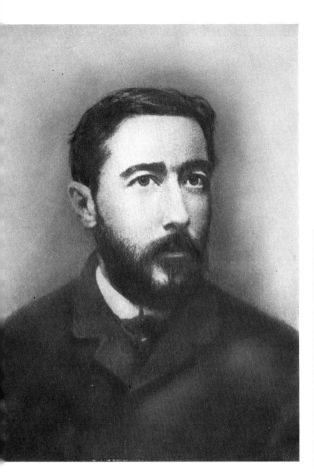

Conrad at twenty-five, photographed during his
stay in Marienbad with his uncle Thaddeus.

Report of Captain Beard of the *Palestine* on Conrad.

Singapore April 4

This is to certify that
Conrad Korzeniowski served
as Second Mate for eighteen
months on board the Barque
Palestine of London under
my command and that I
can recommend him as a
sober steady man to any
one that may require his ser

E. Beard master
Barque Palestine

(SUBSTITUTE FOR E 1, C 11, AND C C 5.)

CERTIFICATE OF DISCHARGE.

Dis. 1.

For Seamen discharged before the Superintendent of a Mercantile Marine Office in the United Kingdom, a British Consul, or a Shipping Officer in British possession abroad.

SANCTIONED BY THE BOARD OF TRADE, JANUARY 1869.

No. 11

Name of Ship.	Offcl. Number.	Port of Registry.	Registd. Tonnage.
"Riversdale"	29953	Liverpool	1490

Horse Power of Engines (if any.)	Description of Voyage or Employment.
—	Foreign

Name of Seaman.	Age.	Place of Birth.	No. of R. N. R. Commissn. or Certif.	If Mate or Engineer No. of Certif. (if any.) Capacity.
Conrad Korzeniowski	26	Poland	—	2nd Mate

Date of Engagement.	Place of Engagement.	Date of Discharge.	Place of Discharge.
10th Sept/83	London	17 Apl/84	Madras.

I certify that the above particulars are correct, and that the above-named Seaman was discharged accordingly* and that the character described on the other side hereof is a true copy of the Report concerning the said Seaman.

Dated this 17th day of April 18 84 AUTHENTICATED BY

L B McDonald Master. Signature of Superd., Consul, or Shipping Officer

NOTE.— Any person who makes, assists in making or procures to be made any false Certificate or Report of the Service, Qualifications, Conduct or Character of any Seaman, or who forges, assists in forging or procures to be forged, or fraudulently alters, assists in fraudulently altering, or procures to be fraudulently altered, any such Certificate or Report, or who fraudulently makes use of any Certificate or Report, or of any Copy of any Certificate or Report which is forged or altered or does not belong to him, shall for each such offence be deemed guilty of a misdemeanor and may be fined or imprisoned.

Conrad's certificate of discharge from the sailing ship *Riversdale*, which he left at Madras on 17 April 1884.

The Inquiry into the loss of the *Palestine* was held in Singapore and attended by Conrad, and a reflection of it can most certainly be seen in the Inquiry into the loss of the *Patna* in the novel, *Lord Jim*.

On returning to England in May 1883, Conrad went off for a long-planned meeting with his uncle, the first in almost ten years. They stayed at Marienbad and then at Töplitz where the young seaman, now twenty-five, was photographed.

He left his next ship – the *Riversdale*, a sailing ship of 1,500 tons, bound for the East – at Madras, and returned home in another sailing ship, the *Narcissus*, which he joined at Bombay. She was 'a lovely ship, with all the graces of a yacht' and as second mate he sailed in her to Dunkirk. This ship and her voyage formed the basis for *The Nigger of the 'Narcissus'*. Though Conrad denied that James Wait, the nigger of the story, was one of the *Narcissus'* crew, he conceded, 'Most of the personages I portrayed actually belonged to the crew of the real *Narcissus*.' The story is Conrad's masterpiece of the sea.

It was on this occasion, according to Hope, that for the first and only time Conrad brought a pet from abroad – a monkey which

tore up a lot of important papers in Krieger's office at Barr, Moering & Co., and had to be 'disposed of . . . to a Jew in the Minories'.

Conrad's next voyage to the Far East was in the *Tilkhurst* which sailed from Hull in April 1885. While she was coaling at Cardiff, Conrad met Spiridion Kliszczewski, son of a Polish immigrant and watch-maker, and became friendly with him, a friendship which lasted for some years. It was when Conrad was in Singapore during this voyage that his first extant letters in English were written to Kliszczewski. They give us some insight into his thoughts at that time. He saw England as 'the only barrier to the pressure of infernal doctrines born in continental back-slums' and at the same time he expresses his plan to take up whale-fishing, or, alternatively, to go into commerce: 'I am sick and tired of sailing about for little money and less consideration.'

In 1887, Conrad's fourth and final, but longest and most fruitful visit to the Far East began when he signed as first mate on the *Highland Forest* on 16 February. She was bound for Samarang in Java, and he joined her in Amsterdam:

I call to mind a winter landscape in Amsterdam – a flat foreground of waste land, with here and there stacks of timber, like the huts of a camp of some very miserable

Bombay Harbour. Conrad joined the famous *Narcissus* here in April 1883, after leaving the *Riversdale*.

(*Above*) the *Tilkhurst* at San Francisco. Conrad served in this sailing ship as second mate, voyaging to Singapore. He said of her captain that he was 'one of the best seamen whom it has been my good luck to serve under'.

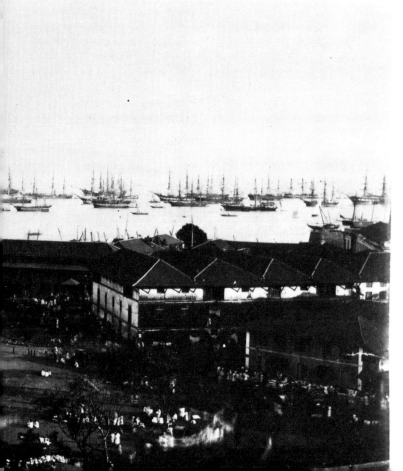

(*Left*) view of the Amsterdam café – 'an immense place, lofty and gilt, upholstered in red plush' – from where Conrad wrote to the owners of the *Highland Forest*.

(*Right*) Samarang, Java. Conrad left the *Highland Forest* here and went into hospital in Singapore, as did his hero Lord Jim.

tribe ... the snow-sprinkled ground and the hard, frozen water of the canal, in which were set ships one behind another with their frosty mooring-ropes hanging slack and their decks idle and deserted, because ... their cargoes were frozen-in up-country on barges and schuyts ... I was chief mate, and very much alone. ... Notwithstanding the little iron stove, the ink froze on the swing-table in the cabin ... I found it more convenient to go ashore stumbling over the Arctic waste land and shivering in glazed tramcars in order to write my evening letter to my owners in a gorgeous café in the centre of the town ... an immense place ... upholstered in red plush, full of electric lights, and so thoroughly warmed that even the marble tables felt tepid to the touch.

Conrad was chief mate for the first time and the fact of his elevation kept him warm 'better than the high pile of blankets'. Since the captain had not yet arrived, Conrad was in charge of stowing the cargo. It was after loading was completed that a stranger in a black bowler and a short drab overcoat appeared on the quay – the captain, John McWhirr. His response to Conrad's report that he had stowed the cargo with one-third in weight 'above the beams' was, 'Well, we shall have a lively time of it this passage.' And they did. 'The captain in his armchair, holding on grimly at the head of the table, with the soup-tureen rolling on one side of the cabin and the steward sprawling on the other, would observe, looking at me: "That's your one-third above the beams."' It is understandable that the laconic Captain McWhirr became the inspiration for that fictional McWhirr who took the *Nan-Shan* with her coolie passengers safely through the storms in *Typhoon*.

During the *Highland Forest*'s 'lively' passage, her chief mate's back was injured by a flying spar, and he became subject to 'inexplicable periods of powerlessness, sudden accesses of mysterious pain'. A Dutch doctor in Samarang expressed his fears: 'Ah, friend, you are young yet; it may be very serious for your whole life. You must leave your ship; you must quite silent be for three months – quite silent.' On the advice of the doctor Conrad was shipped to Singapore, where he entered hospital. The material for his later Eastern novels was all about him; the foundations of his next career were being laid. Singapore was to be the 'great Eastern port' of *Lord Jim*, *The End of the Tether*, *The Rescue* and *The Shadow-Line*.

It was a thriving port with a busy harbour, a city containing a vivid mixture of races, as it does today: Conrad's descriptions ring as true now as then. There is the Esplanade with its 'avenues of big trees', white cathedral and 'ordered grass plots'; Chinatown, the bustle of commerce, the 'swarm of brown and yellow humanity' filling a thoroughfare where 'the shops of the Chinamen yawned like cavernous lairs'; 'heaps of nondescript merchandise [overflowing] the long range of arcades'; and in the distance 'ships like toys with the eternal serenity of the eastern sky and the smiling peace of the Eastern seas'. Conrad would still be fascinated today, if he could return, by the sweep of the boat quay, the thousand sampans, the lighters discharging cargo, each vessel with a huge eye painted on the bows to keep off devils, and the whole 'absolutely riotous with life'.

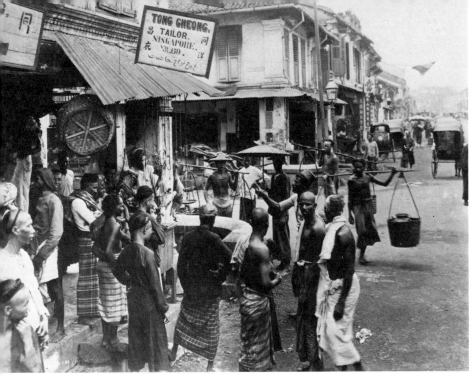

(*Above*) street scene in Singapore, *c.* 1890. 'The fiery serenity of sunset . . .
fell on the bright colours and the dark faces of the bare-footed crowd, on the
pallid yellow backs of the half-naked jostling coolies.' (*The End of the
Tether*)

Boat Quay, Singapore, *c.* 1890. 'Jorgenson pointed at the mass of praus,
coasting boats, and sampans that, jammed up together in the canal, lay
covered with mats and flooded by the cold moonlight, with here and there
a dim lantern burning amongst the confusion of high sterns, spars, masts,
and lowered sails.' (*The Rescue*)

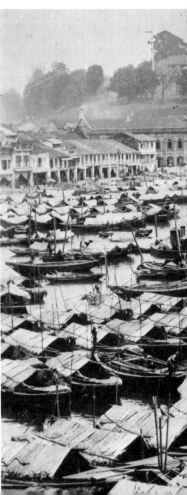

42

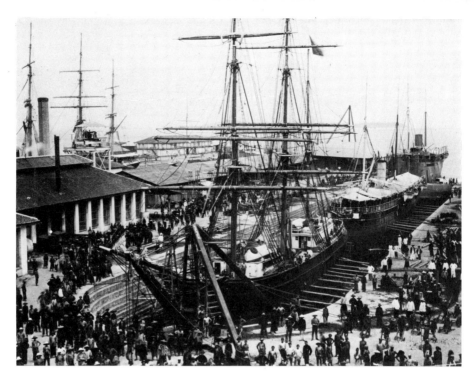

Dock at Singapore,
c. 1890.

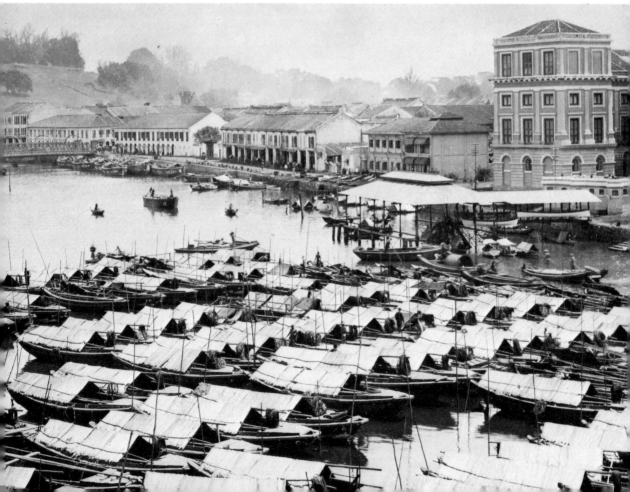

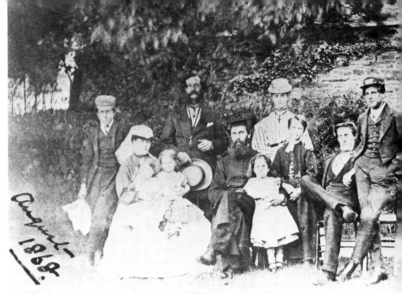

Augustus Podmore Williams –
first mate of the *Jeddah* and the main
source for Lord Jim – with his young
wife in Singapore, *c.* 1883, and
(standing, *far right*) as a young sea-
man at his father's rectory, Porthleven
Parsonage, in 1868. In *Lord Jim*
Conrad wrote: 'Originally he came
from a parsonage. . . . The living had
belonged to the family for genera-
tions. . . . Jim was one of five sons.'
And he described Jim as 'an inch,
perhaps two, under six feet, power-
fully built, and he advanced straight
at you with a fixed from-under
stare.'

Lord Jim and the narrator in *The Shadow-Line* stayed, as Conrad did, at the Sailors' Home, and knew the Harbour Office to which Conrad was summoned by the Master-Attendant of the port, Captain Henry Ellis.

The East, and especially Singapore, was peopled with men who appear in Conrad's fiction. Augustus Podmore Williams, a ship-chandler's water-clerk in the port, had been mate of the pilgrim ship *Jeddah* which sailed from Singapore in 1880 and was abandoned by her European officers after a storm, leaving 1,000 Moslem pilgrims to their doom. The captain cabled from Aden that their ship had foundered and all the pilgrims had perished, but the following day the *Jeddah* was towed in to Aden harbour by the *Antenor* with all the pilgrims safe on board. The event created a scandal which would not die out and this was the source for *Lord Jim*. Captain Ellis, the despotic Master-Attendant, appears in three of Conrad's novels as 'the deputy-Neptune for the circumambient seas. If he did not actually rule the waves, he pretended to rule the fate of the mortals whose lives were cast upon the waters.' According to his grandson, 'he struck terror into all his subordinates, whether oriental or occidental; his word was law and he always spoke with the authority of a man who was not accustomed to having his opinions controverted. He ruled with a rod of iron.' Even the steward of the Sailors' Home, who had at some time been connected with the sea – 'possibly in the comprehensive capacity of a failure' – was faithfully represented by Conrad.

On 22 August, Conrad, now discharged from hospital, decided against returning to England, and was taken on as mate of the steam-ship *Vidar*, whose captain, Craig, told Jean-Aubry that he first met

44

Conrad 'at the Shipping-Office of Singapore about the middle of August 1887': 'He pleased me at once by his manners, which were distinguished and reserved. One of the first things he told me was that he was a foreigner by birth, which I had already guessed from his accent. I replied that it did not matter in the least. . . . (It was quite difficult at that time to find officers in the East who were not over fond of the bottle.)'

The *Vidar* was a local ship, owned by an Arab called Syed Mohsin Bin Saleh Al Jooffree, who was well known and liked in Singapore. As Conrad wrote: 'He was head of a great House of Straits Arabs, but as loyal a subject of the complex British Empire as you could find east of the Suez Canal . . . he had a great occult power amongst his own people.' The *Vidar* traded among the islands of the South-East Asian archipelago, and Conrad stayed with her four and a half months, repeating the journey as it is described in *The Shadow-Line* and *The End of the Tether*:

. . . from Singapore through the Carimata Strait, from South Borneo to Benjar-massim, then between the Isle of Pulo Laut and the coast of Borneo. She coaled at Pulo Laut, touched at Dongola on the western coast of Celebes, returned to Coti Berau, and finally reached Bulungan [returning by] the same route to Singapore.

As part of the journey, the *Vidar* travelled up the Berau River in Borneo, and here Conrad discovered another area that was to be a fruitful source for his later novels. The Berau, with its small Malay settlement of Tandjong Redeb, forty miles up the river, 'one of the lost, forgotten, unknown places of the earth', appears in *Almayer's Folly*, *An Outcast of the Islands* and *Lord Jim*. A photograph from Australian Intelligence shows the settlement Conrad knew; 'The

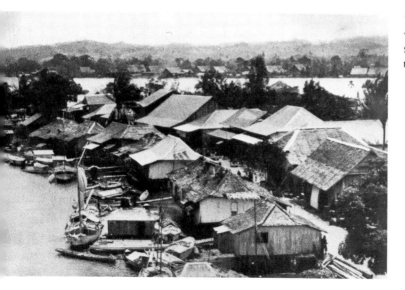

Tandjong Redeb, the Bornean village Conrad visited as mate of the s s *Vidar* in 1887 and where he met the source for Almayer.

(*Right*) a typical Malay house of the period.

(*Below*) Charles Olmeijer, a damaged but unique photograph of Conrad's source for Almayer of *Almayer's Folly*.

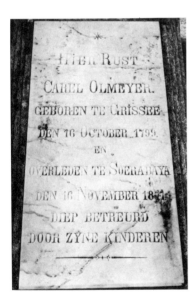

Olmeijer's grave, Surabaya.

houses crowded the bank, and, as if to get away from the unhealthy shore, stepped boldly into the river, shooting over it in a close row of bamboo platforms elevated on high piles. . . . There was only one path in the whole town. . . .' It was here that Conrad first met Charles Olmeijer, a trader, who was to become his scapegoat hero, Almayer:

I had heard of him at Singapore; I had heard of him on board, . . . I had heard of him in a place called Pulo Laut from a half-caste gentleman there . . . I had heard of him in a place called Dongola, in the Island of Celebes, when the Rajah of that little-known sea-port . . . came on board in a friendly way . . . and drank bottle after bottle of soda-water . . . I had seen him for the first time . . . from the bridge of a steamer moored to a rickety little wharf forty miles up, more or less, a Bornean river. . . . He stepped upon the jetty. He was clad simply in flapping pyjamas of cretonne pattern . . . and a thin cotton singlet with short sleeves.

It was here also that Conrad learnt of the influence of Captain William Lingard, who had surveyed the Berau and had a channel named after him in the charts, who had fought pirates and was known as the 'Rajah Laut' (King of the Seas) by the Malays, who established Olmeijer (and later his nephew Jim Lingard) at the trading post at Tandjong Redeb, and another nephew, Joshua, in Singapore. Captain Lingard owned the *Coeran*, the *West Indian* and the *Rajah Laut*, and a local newspaper described him as 'a person-

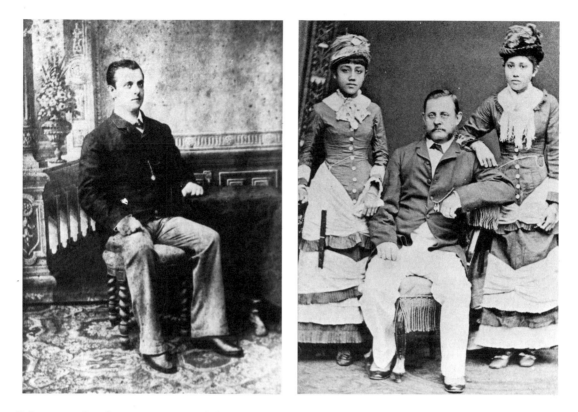

age of almost mythical renown, a sort of ubiquitous sea-hero, perhaps at times a sort of terror to evildoers, all over Eastern waters from Singapore to Torres Straits, and from Timor to Mindanao.' He finally returned to England, and died in Ashton near Macclesfield. William Lingard became, in recognizable form, the Captain Tom Lingard of Conrad's early Eastern novels and of *The Rescue*.

Conrad's amazingly accurate knowledge of these people derived from a few short visits to the East. That he was writing about persons well known in that area – though not in the West where his novels were published – is shown by a review of *An Outcast of the Islands* in the Singapore newspaper *Straits Budget* of 1896:

It is very much to be regretted that, in this novel as in *Almayer's Folly*, Mr Conrad should have given to the most interesting figure the name of a man who has actually played a real part in the history of the Archipelago. . . . In justice to the author we must add that the portrait of the deceased 'Rajah Laut' whether true or not, is calculated to enlist the sympathies of the reader. . . . Our inquiries have only given us reason to believe that the portrait of the 'Rajah Laut' is not the only one drawn from real life.

On 4 January 1888, Conrad, again unpredictably, gave up his berth on the *Vidar*, and there began that series of events leading up to his first – and only – command, which he chronicled, with some

(*Left*) Jim Lingard (nephew of Captain William Lingard) who with Olmeijer traded at Tandjong Redeb.

Captain William Lingard, known by the Malays as 'Rajah Laut', the King of the Seas. He was the model for Conrad's Captain Tom Lingard.

47

imaginative distortion, in *The Shadow-Line*. It was the Master-Attendant of Singapore, Captain Ellis, who gave Conrad command of a small barque, the *Otago*, then in Bangkok. The Captain, John Snadden, had died during the previous voyage and had been buried at sea; the mate, Charles Born, brought the ship into Bangkok. There had been difficulty in finding another captain, probably because the *Otago* was a sailing ship and carried a white crew – 'Too much trouble. Too much work,' as Ellis says in *The Shadow-Line*. But Conrad accepted the command. In the Public Record Office in London I discovered the following letter from Ellis, dated 19 January 1888, to the Consul at Bangkok, describing Conrad and his conditions of employment:

The person I have engaged is Mr Conrad Korzeniowski, who holds a certificate of Competency as Master from the Board of Trade. He bears a good character from the several vessels, he has sailed out of this Port. I have agreed with him that his wages at £14 per month to count from date of arrival at Bangkok.

Conrad arrived in Bangkok on 24 January and had his first view of his command:

(*Right*) Captain John Snadden, master of the *Otago* before Conrad, who was buried at sea probably off Cap St Jacques on the coast of Cochin-China and whose spirit is important to Conrad's *The Shadow-Line*. (*Left*) first page of a letter taken down by the first mate, Charles Born, two days before the death of Captain Snadden: 'I may linger on a little longer but finally in a few hours or days I must say good bye to all.'

At the first glance I saw that she was a high-class vessel, a harmonious creature in the lines of her fine body, in the proportioned tallness of her spars. Whatever her age and history, she had preserved the stamp of her origin . . . she looked like a creature of high breed – an Arab steed among a string of cart-horses.

The *Otago*, Conrad's first command, 1888.

The *Otago* had been built in Glasgow in 1869, she was 367 tons gross, and whatever troubles he had initially in taking her over, Conrad always spoke of her with affection: 'my first command . . . sure of a tenderly remembered existence as long as I live.'

At the beginning of *The Secret Sharer*, Conrad gives a magnificent description of the River Meinam and the city of Bangkok as they appeared to a ship lying outside the bar:

On my right hand there were lines of fishing-stakes resembling a mysterious system of half-submerged bamboo fences. . . . To the left a group of barren islets, suggesting ruins of stone walls, towers, and blockhouses. . . . And when I turned my head to take a parting glance at the tug which had left us anchored outside the bar, I saw

49

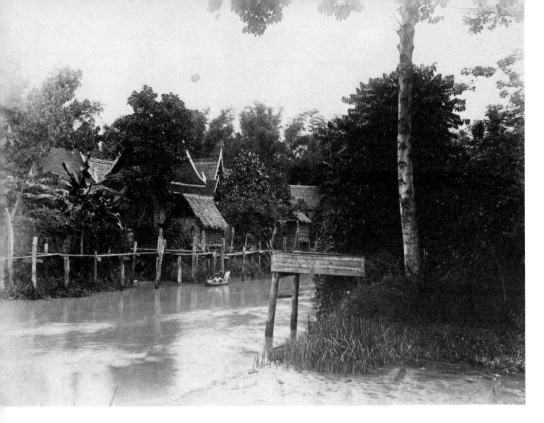

Canal, Bangkok, *c.* 1890.

the straight line of the flat shore joined to the stable sea . . . two small clumps of trees . . . marked the mouth of the River Meinam . . . and, far back on the inland level, a larger and loftier mass, the grove surrounding the great Paknam pagoda. . . . Here and there gleams as of a few scattered pieces of silver marked the windings of the great river; and on the nearest of them, just within the bar, the tug steamed right into the land became lost to my sight. . . .

During his brief stay Conrad knew the city only as a sailor would, superficially; though he was involved in an incident which was reported in the local press:

A Chinese 'boy' employed on the barque *Otago* managed the other day to steal 15 gold mohurs from a sailor on board, and then to abscond. The captain and mate, however, met the juvenile thief a few hours afterwards in Mr Clarke's compound and arrested him. Whilst being conducted to the Bang Rak Police Station, he unfortunately managed to bolt and has not since been seen. But Mr Clarke's cook, a man named Kam Kow, at once offered a cattie of silver if the matter was quashed and this fact, coupled with his being found in possession of 15 ticals, raised suspicion, so Kam Kow is now in jail. He appears to have been a friend of the 'boy' and thus probably knows his present whereabouts . . . (*Bangkok Times*, 1 February 1888).

But the whole area provided the material for *The Shadow-Line*, *Falk* and *The Secret Sharer*. Conrad faced immediate difficulties, with the charterers and in getting cargo, and there was severe sickness among the crew. William Willis, physician to the British Legation in Siam, confirmed that 'the crew of the sailing ship *Otago* has suffered

severely whilst in Bangkok from tropical diseases, including fever, dysentery and cholera'. Thus Conrad had command of a cholera-infected vessel. A certificate attached to the crew-list records the death of at least one member of the crew, who was buried in Bangkok.

The *Otago*, after much delay, at last left for her journey of 800 miles down the Gulf of Siam to Singapore, a journey which took three weeks instead of the customary few days because of the lack of wind, and which was dogged by sickness. Some indication of the dreadful experience of Captain Conrad while waiting for the windless conditions in the Gulf of Siam to change appears in *The Shadow-Line*:

I remain on deck . . . night and day, and the nights and the days wheel over us in succession, whether long or short, who can say? All sense of time is lost in the monotony of expectation, of hope, and of desire – which is only one: Get the ship to the southward! Get the ship to the southward! The effect is curiously mechanical; the sun climbs and descends, the night swings over our heads as if somebody below the horizon were turning a crank. It is the pettiest, the most aimless! . . . and all through the miserable performance I go on, tramping, tramping the deck. How many miles have I walked on the poop of that ship! A stubborn pilgrimage of sheer restlessness.

Her arrival in Singapore was announced in the *Singapore Free Press*: '*Otago*, Brit. Bk., 349, Korgemourki [*sic*], Bangkok, Feb. 9. Rice, Master – put in for medical advice. Outside Harbour Limits.' A second report states that the master wanted a further supply of medicine, and that three of the crew had been sent to hospital.

After this nightmarish voyage, the *Otago* went on to Sydney, arriving there on 7 May: 'Arrivals – May 7 *Otago*, barque, 347 tons. Captain Konkorzentowski [*sic*] from Bangkok' (*Sydney Morning Herald*). Conrad remained with this ship, sailing next to Mauritius where he spent three weeks. By chance, we have quite a lot of information about those three weeks. There is, to begin with, a description, by one of the ship's charterers, of Conrad's appearance at the age of thirty-one, which shows that Conrad the seaman was still conscious of his Polish heritage:

. . . Captain Korzeniowski was always dressed with great elegance. I can still see him . . . arriving in my office almost every day dressed in a black or dark coat, a vest that was usually light in colour, and fancy trousers; everything well cut and very stylish; on his head a black or grey derby tilted slightly to one side. He invariably wore gloves and carried a cane with a gold knob. . . . He was not . . . very popular with his colleagues, who sarcastically called him 'the Russian Count'.

Conrad became quite intimate with one of the old French families, which he describes in *A Smile of Fortune* as 'descendants of the old colonists; all noble, all impoverished, and living a narrow domestic life in dull, dignified decay. The men, as a rule, occupy inferior posts in Government offices or in business houses. The girls are almost always pretty, ignorant of the world, kind and agreeable and generally

bilingual; they prattle innocently both in French and English.' A questionnaire which he answered, entered in an 'Album of Confidences', suggests the nature of his intimacy with the family, and his signing it 'J.K.C.' suggests he was in the process of simplifying a name which never failed to give difficulty to the press. Of the pretty, bilingual girls, Conrad fell in love with one called Eugénie Renouf, but on learning from her brother that she was already engaged he stayed aboard the *Otago* for the last two days before sailing, and vowed never to return to Mauritius.

At the end of March 1889, Conrad abruptly resigned his command. The action was in his tradition of throwing up jobs for curious and obscure motives. Perhaps the area had lost its charm for him, certainly his uncle had written the previous September, pleading with him to return: 'for an old man the time he has left is a matter of some interest, and so is the knowledge that he may see once more those who are dear to him.' He resigned of his own accord and to the dismay of his employers who wrote to him: 'this early severance from our employ is entirely at your own desire. . . . And we entertain a high opinion of your ability in the capacity you now vacate.'

Conrad left Adelaide for Europe on 3 April in the s s *Nürnberg*. In the passenger list he is for the first time called Captain Conrad. Back in London in the early summer of 1889, he was once more without a job, and in the situation he ascribed to Marlow at the beginning of *Heart of Darkness*:

I had then, as you remember, just returned to London after a lot of Indian Ocean, Pacific, China Seas – a regular dose of the East – six years or so, and I was loafing about, hindering you fellows in your work and invading your homes, just as though I had got a heavenly mission to civilize you. It was very fine for a time, but after a bit I did get tired of resting. Then I began to look for a ship – I should think the hardest work on earth. But the ships wouldn't even look at me.

His uncle again expressed a hope of seeing him soon – they had not met since 1883 – but Conrad had yet to receive the formal release from his allegiance to the Tsar which would make his return to Poland safe. He seems at this time to have worked for Barr, Moering & Co., the firm of shipping agents with whom he had invested some money through his friend Krieger, but, according to his own account, this period of land bound inactivity had a great significance for him since it was at this time, in his Bessborough Gardens lodgings in London, that he began to write his first novel, *Almayer's Folly*:

That morning I got up from my breakfast, pushing the chair back, and rang the bell violently. . . . It was an unusual thing for me to do. Generally, I dawdled over my breakfast and I seldom took the trouble to ring the bell for the table to be cleared away; but on that morning for some reason hidden in the general mysteriousness of the event I did not dawdle. . . . It is very clear that I was in no haste to take the plunge into my writing life. . . . My whole being was steeped deep in the indolence of

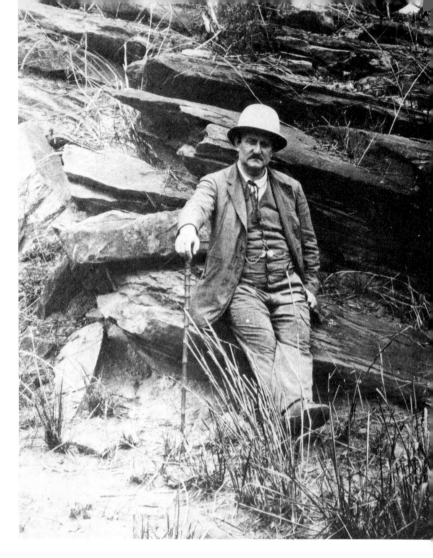

Captain Albert Thys, 1892, of the Belgian company that employed Conrad in the Congo.

the sailor away from the sea, the scene of never-ending labour and of unceasing duty. . . . What I am certain of is, that I was very far from thinking of writing a story, though it is possible and even likely that I was thinking of the man Almayer.

During the next five years, the manuscript accompanied Conrad on his travels – it was added to in the cabin of the *Adowa* alongside a quay in Rouen; it was providentially saved from the Congo rapids; it was read by a passenger on the *Torrens* bound for Australia; it was carried in his luggage to the Ukraine.

But at the novel's inception in the summer of 1889, he was still without a berth, and on 24 September, G. de Baerdemacker, a ship-broker at Ghent, wrote to Captain Albert Thys, acting manager of the Société Anonyme Belge pour le Commerce du Haut-Congo in Brussels, asking whether it would be possible to employ Conrad in the Congo: 'This gentleman is very warmly recommended to me

Sir Henry Morton Stanley, the famous African explorer and founder of the Congo Free State for the King of the Belgians. His activities excited Conrad's interest in the Congo.

Madame Marguerite Poradowska, widow of Conrad's cousin. She was an established novelist herself and for many years maintained a close correspondence with Conrad. Thaddeus Bobrowski warned against close friendship with this 'patched up grannie'.

by friends in London and holds the highest certificates: his general education is superior to that of most seamen and he is a perfect *gentleman*.'

Conrad's restless spirit, which had already driven him across most of the world, plus the necessity of earning a living, was no doubt responsible for this desire to go to the Congo. He appears, from an early age, to have had an ambition to see Africa:

Now when I was a little chap I had a passion for maps. . . . At that time there were many blank spaces on the earth, and . . . I would put my finger on [one] and say, When I grow up I will go there. . . . But there was one yet – the biggest, the most blank, so to speak – that I had a hankering after. . . . True, by this time it was not a blank space any more. . . . It had ceased to be a blank space of delightful mystery – a white patch for a boy to dream gloriously over. It had become a place of darkness. But there was in it one river especially, a mighty big river, that you could see on the map, resembling an immense snake uncoiled. . . .

This was the Congo, but Africa generally for Conrad had the heroic and adventurous attraction of the great explorers – 'the single-minded explorers of the nineteenth century, the fathers of militant geography whose only object was the search for truth'. Africa for him was Mungo Park, Bruce, Burton and Speke, Dr Livingstone, and the desire to go to Africa was bound up with ideals of selfless heroism and adventure.

During that summer of 1889, Africa had been very much in the news again. Henry Morton Stanley's expedition from Zanzibar to the Lower Congo took place in 1876–7; afterwards, he was employed by King Leopold of the Belgians to establish trading posts across Central Africa; and in 1889, following his successful and much publicized search for Livingstone, with its laconic climax – 'Dr Livingstone, I presume' – Stanley was again in the news through his search for and relief of Emin Pasha. It was against this background that Conrad made strenuous efforts to get to the Congo, and ultimately fulfilled his boyhood ambition in 'a wretched little stern-wheel steamboat . . . moored to the bank of an African river. . . . Everything was dark under the stars . . . I have smoked a pipe of peace at midnight in the very heart of the African continent, and felt very lonely there.'

In November 1889 Conrad was interviewed in Belgium by Thys ('an impression of pale plumpness in a frock-coat'), but it was not until April of the following year that he obtained a post with the Société Anonyme Belge. Meanwhile, in February 1890 he began his visit to Poland and his uncle. He stopped in Belgium to make the acquaintance of a distant cousin whose wife, Marguerite Poradowska (very soon to be widowed), had influence with the Société Anonyme Belge and was a publishing author. This was the beginning of a long and intimate friendship with his 'aunt' as Conrad called her, carried on mainly by letter. Madame Poradowska was in her early

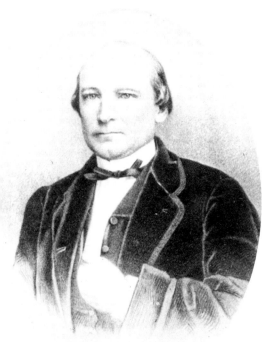

Thaddeus Bobrowski, *c.* 1890.

The first page of Thaddeus Bobrowski's 'Document', the full account of Conrad's upbringing, which was presented to him in 1890.

forties, and renowned for her beauty. Conrad's wife later wrote that 'she was, I think, the most beautiful woman I had ever seen.' She was also the statuesque, forceful kind of woman to whom Conrad seems to have been always attracted but also somewhat awed by, if we judge by the women in his stories.

Conrad went to Poland, which he had left sixteen years earlier, to his uncle's estate in Kiev. Thaddeus presented him with his 'Document', the full account of his upbringing: '*Thus the making of a man out of Mr Konrad has cost* – apart from the 3,600 roubles given you as capital – 17,454 roubles.' His uncle was against the Congo plan, but on his return to England Conrad found that there was an opening for him as a steamer captain on the river due to the assassination

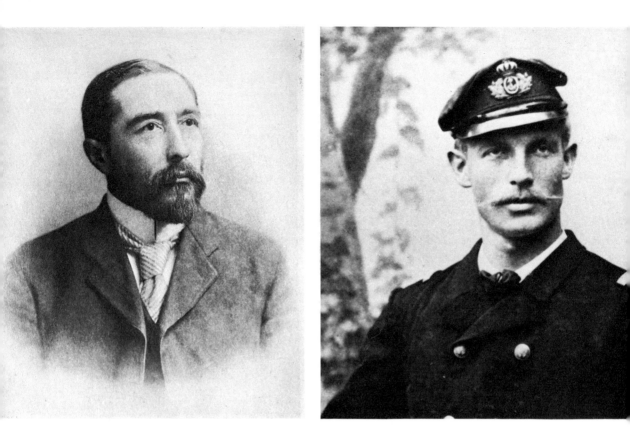

A photograph of Conrad taken before he set off for the Congo in 1890.

(*Right*) Captain Freiesleben, master of the river steamer *Florida*, assassinated by natives in the Congo: 'When an opportunity offered at last to meet my predecessor, the grass growing through his ribs was tall enough to hide his bones. They were all there.' (*Heart of Darkness*)

by natives of the young Captain Freiesleben – he was twenty-nine – at Tchumbiri. A missionary at that time recorded of Freiesleben three months after his death that he was 'still unburied – his hands and feet have been cut off – his clothes taken away and his body covered in a native cloth. . . . The hair is cut off and made into a fringe and tied round his face.'

Conrad sailed in a French ship, the *Ville de Maceio*, on 10 May. In a letter he wrote: 'We left Bordeaux on a rainy day . . . haunting memories; vague regrets; still vaguer hopes. One is sceptical of the future.' He had good reason for such scepticism, for the journey to the Congo and up that great river was to be a journey into disillusionment, where the outstanding concerns of the Government and traders were with bureaucracy and their greed for ivory. Even before the *Ville de Maceio* arrived at Boma, Conrad was writing to his cousin Karol Zagórski about the fact that 60 per cent of the company's employees returned to Europe before completing six months' service, as a result of fever and dysentery; and in a characteristically ironic manner, he adds: 'There are others who are sent home in a hurry at the end of a year, so that they shouldn't die in the Congo. God forbid! It would

spoil the statistics which are excellent, you see!' Conrad's experience was to be humiliating, frustrating and distasteful, as well as disastrous in terms of his future health, but his sharpness of eye and recall of events when he came to write his greatest story, *Heart of Darkness*, were precise and evocative. He did part of the great journey overland, from Matadi to Kinchassa, and in his Congo diary (the only diary that has survived) – two small black penny notebooks – he briefly records some of his gruelling experiences. For one thing his European companion on the trek, Harou, was sick most of the journey, 'vomiting bile in enormous quantities'. And the nightmare quality of the story exists also in the diary: 'Met an officer of the State inspecting. A few minutes afterwards saw at a camping place the dead body of a Backongo. Shot? Horrid smell.' And the next day: 'Saw another dead body lying by the path in an attitude of meditative repose.'

Perhaps the only good that came out of the experience was his meeting with Roger Casement at Matadi on 13 June 1890. Many years later Conrad was to describe him as having 'a touch of the Conquistador in him'. He recalled: 'I've seen him start off into an unspeakable wilderness swinging a crookhandled stick for all weapons, with two bulldogs . . . at his heels and a Loanda boy carrying a bundle for all company. A few months afterwards . . . I saw him come out again, a little leaner, a little browner, with stick, dogs and Loanda boy,

Roger Casement, the Irish patriot who was later to be hanged for treason, in the Congo where Conrad met him in June 1890.

Camille Delcommune, manager of the Kinchassa station. 'He was heard to say, "Men who come out here should have no entrails." ' (*Heart of Darkness*)

Alexandre Delcommune, Camille's brother and leader of the Katanga Expedition. 'To tear treasure out of the bowels of the land was their desire, with no more moral purpose at the back of it than there is in burglars breaking into a safe.' (*Heart of Darkness*)

and quietly serene as though he had been for a stroll in a park.' Casement, who in 1903 was to take part in exposing the atrocities perpetrated in the Congo, was knighted in 1911, but degraded and executed for high treason in 1916.

But if he liked Casement, he developed a deep hatred and resentment for Camille Delcommune, manager of the Kinchassa station and his immediate superior. Conrad's first biographer, Jean-Aubry, recalled that, from Conrad's reminiscences about the Congo, 'what remains most vividly in my mind is, first the landscape with the river wide as a sea . . . and second, the hostile and disagreeable figure of Camille Delcommune.' Something of Conrad's feeling towards Delcommune is shown in a letter written from the Congo: 'The manager is a common ivory-dealer with sordid instincts who considers himself a merchant though he is only a kind of African shopkeeper.' Camille Delcommune's brother, Alexandre, was then leading an expedition, known as the Katanga Expedition, which was to explore the Lomami River, and Conrad had expected to take command of their steamer. It would seem, however, that Alexandre shared his brother's hostility, and the expedition went off without Conrad. Perhaps this accounts for Conrad's malicious portrait of Alexandre in *Heart of Darkness*: 'he resembled a butcher in a poor neighbourhood, and his eyes had a look of sleepy cunning. He carried his fat paunch with ostentation on his short legs.'

Conrad's experience of the Congo was short-lived. He made only once the 1,000-mile trip up that mighty river to Stanley Falls and back

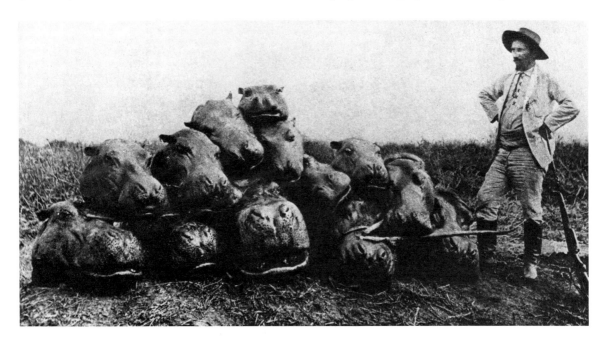

again in a wood-burning stern-wheeler, the *Roi des Belges*, a mere fifteen tons, which he disparagingly calls a 'tin-pot steamer', 'like an empty Huntley and Palmer biscuit tin', 'a two-penny-halfpenny river steamboat with a penny whistle attached'. 'Going up that river [he wrote] was like travelling back to the earliest beginnings of the world, when vegetation rioted on the earth and the big trees were kings. . . . The reaches opened before us and closed behind, as if the forest had stepped leisurely across the water to bar the way for our return. We penetrated deeper and deeper into the heart of darkness. It was very quiet there.'

At the Stanley Falls station he experienced a profound disillusion-ment:

The subdued thundering mutter of the Stanley Falls hung in the heavy night air of the last navigable reach of the Upper Congo. . . . A great melancholy descended on me . . . there was no shadowy friend to stand by my side in the night of the enormous wilderness, no great haunting memory, but only the unholy recollection of a prosaic newspaper 'stunt' and the distasteful knowledge of the vilest scramble for loot that ever disfigured the history of human conscience.

Fever and dysentery were rife at Stanley Falls, and Conrad and others, including Georges Antoine Klein, the company's agent there, were very sick. Conrad recovered sufficiently to command the little vessel and take her downstream: 'The brown current ran swiftly out of the heart of darkness bearing us down towards the sea.' On that down-river trip Klein, who as Kurtz was to become the hero of *Heart of Darkness*, was buried at Tchumbiri; the death is reported in Conrad's story by the manager's insolent black boy: 'Mistah Kurtz – he dead.'

(*Left*) the *Roi des Belges*, in which Conrad travelled up the Congo to Stanley Falls. 'Trees, trees, millions of trees, massive, immense, running up high; and at their foot, hugging the bank against the stream, crept the little begrimed steamboat, like a sluggish beetle crawling on the floor of a lofty portico.' (*Heart of Darkness*)

The port of Leopoldville in 1887 with the *A.I.A.* and *Ville de Bruxelles*, part of the flotilla on the Congo during Conrad's stay there.

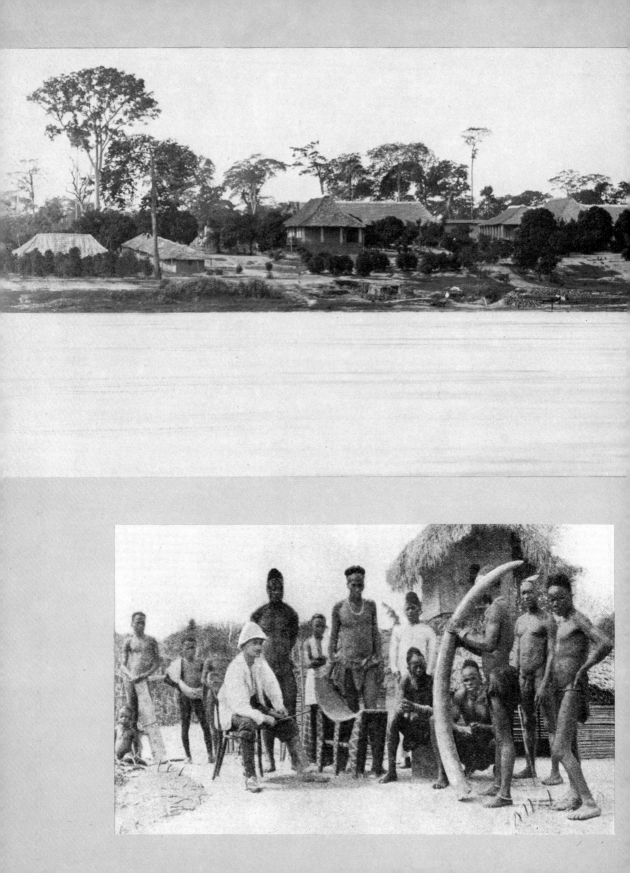

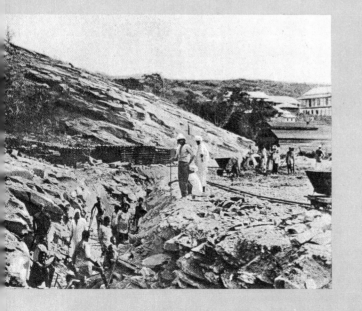

(*Above*) Stanley Falls – Conrad's Heart of Darkness – photograph taken by a missionary in 1896.

(*Far left*) buying ivory in the Congo *c.* 1890. 'The word "ivory" rang in the air, was whispered, was sighed. You would think they were praying to it.' (*Heart of Darkness*)

(*Left*) building the railway at Matadi: 'an undersized railway truck lying there on its back with its wheels in the air. . . . They were building a railway.' (*Heart of Darkness*)

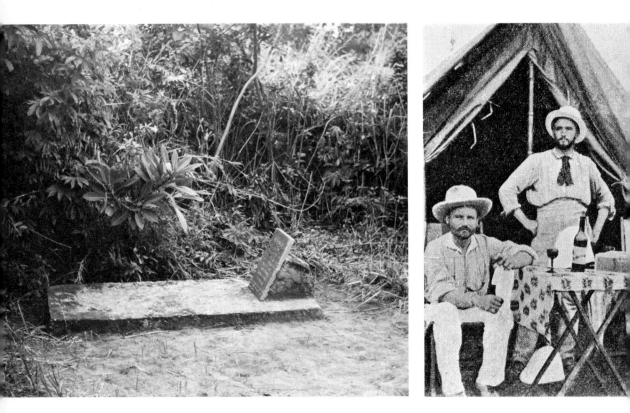

The grave of Georges Antoine Klein, the model for Kurtz in *Heart of Darkness*, at Tchumbiri on the Congo.

Captain Duhst (seated), who made part of the overland journey down-river with the sick Conrad during October in 1890.

In *Heart of Darkness* the narrator, Marlow, tells us that Kurtz was buried in a muddy hole. After a prodigious search a missionary found and interviewed for me an old negress who recalled seventy-eight years after the event seeing Klein, Kurtz's original, being buried.

And Conrad himself, soon afterwards, came near death: 'I have wrestled with death. It is the most unexciting contest you can imagine.' Because of his illness, Conrad was released from his contract with the Société Anonyme Belge and made his way down-river. On this lonely journey, he first made the short trip from Kinchassa to Leopold-ville by native canoe, travelling at night with half the proper number of paddlers. With his usual ironic tone, Conrad comments: 'I failed in being the second white man on record drowned at that interesting point through the upsetting of a canoe.' But he was desperately ill and it took him six weeks to reach the Atlantic coast. An extract from the diary of a Captain Duhst records a meeting with Conrad at this time: 'Camped in a negro town, which is called Fumemba. I am in company with . . . captain Conrad from the Kinchassa Company: he is continually sick with dysentery and fever.'

On his return to England, it was Conrad's friend, Adolf Krieger, who, seeing him half-dead with fever, arranged for the traveller to enter the German Hospital at Dalston, London. Conrad was to

suffer for the rest of his life from malarial gout. From the German Hospital he went on to a hydropathic establishment in Champel, near Geneva, where he completed the eighth chapter of *Almayer's Folly*, and returned almost a month later to London, temporarily in better health.

Once again he worked for Messrs. Barr, Moering & Co., taking over the running of a warehouse, but he was desperately unhappy and sinking into a deep pessimism which lasted throughout most of the year. In May 1891, he wrote to Marguerite Poradowska: 'I am still plunged in deepest night, and my dreams are only nightmares', and in October he was writing: 'This evening I feel as if I were in a corner, spine broken, nose in the dust.' Undoubtedly, Conrad's experience of the Congo was the most devastating of his life and Conrad recognized this when he said later to his friend Edward Garnett: 'Before the Congo, I was just a mere animal.' Conrad's letters of this period are filled with unhappy reflections on his own and man's destiny. But an end was coming to excessive and sombre meditations. He was

Geneva, the Promenade des Bastions. It was near Geneva that Conrad convalesced after returning from the Congo. This Promenade is the setting for parts of *Under Western Eyes*: 'One day I saw Miss Haldin walking alone in the main valley of the Bastions under the naked trees.'

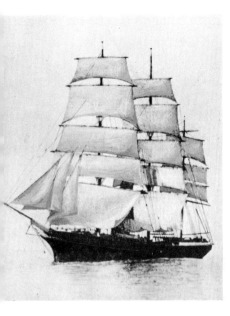

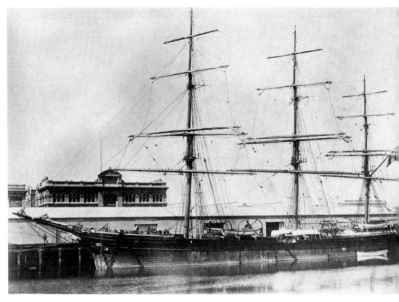

The *Torrens* under sail and in port. 'The way that ship had of letting big seas slip under her did one's heart good to watch.' (*Conrad*)

unexpectedly offered, on 14 November 1891, a berth as first mate on the most famous clipper of them all, the *Torrens*, with her 'celebrated good looks', sailing for Adelaide.

On his second voyage the passengers included Edward Sanderson, son of the headmaster of Elstree Preparatory School, and John Galsworthy, then a very young man just down from Oxford. Galsworthy has left us his first impression of Conrad:

He was superintending the stowage of cargo. Very dark he looked in the burning sunlight, tanned, with a peaked brown beard, almost black hair, and dark brown eyes, over which the lids were deeply folded. . . . He spoke to me with a strong foreign accent. He seemed to me strange on an English ship. . . . Ever a great teller of a tale, he had already nearly twenty years of tales to tell. Tales of ships and storms, of Polish revolution, of youthful Carlist gun-running adventure, of the Malay seas, and the Congo.

Galsworthy's impression of Conrad is, however, at odds with the view we get of him from his letters to his aunt. In his heart at this time Conrad was troubled by real dissatisfaction with his life as a seaman. He speaks of the 'uniform grey of existence' which wearies him and of how his vision is 'circumscribed by the sombre circle where the blue of the sea and blue of heaven touch without merging. Moving in that perfect circle inscribed by the Creator's hand, and of which I am always the centre, I follow the undulant line of the swell – the only motion I am sure of.'

The period from July 1893 to October 1894 was to be of great significance in his life, though he could not then know it. In August he spent a month with his uncle in Poland, and to do this he gave up

his berth on the *Torrens*, a step which worried Thaddeus: 'Consider
... at what cost ... this visit would take place? – your giving up your
present post on the *Torrens*, which you like, and possibly even the
chance of obtaining the command of this ship in the event of Capt
Cope succeeding in his endeavours to get the command of a steam-
ship.' This would suggest that Conrad deliberately gave up an
important step in his career as a seaman. But he soon had reason for
not regretting his action. Although during the month in Poland
Thaddeus was well and it was Conrad who was ill – 'my uncle
looks after me like a boy' – it was to be their last meeting for Thaddeus
had not much longer to live.

Photograph of Conrad inscribed,
'Helen and Ted Sanderson with
much love. J. Conrad 1913.'

John Galsworthy (*left*) and Edward
Sanderson on board the *Torrens*,
1893. 'The first mate is a Pole called
Conrad and is a capital chap, though
queer to look at; he is a man of
travel and experience in many parts
of the world, and has a fund of yarns
on which I draw freely.'
(Galsworthy)

By 1894 the life at sea which Conrad had led for eighteen years, serving
in vessels and often in conditions such as these, had virtually come to a
close; he was then seriously to begin turning this hard-gained experience
into the novels that were eventually to make him famous.

(*Below*) heavy seas coming inboard. 'The deadeyes of the rigging churned
the breaking seas. The lower half of the deck was full of mad whirlpools
and eddies; and the long line of the lee rail could be seen showing black
now and then in the swirls of a field of foam as dazzling and as white as a
field of snow.' (*Right*) seamen furling canvas on a barque in heavy
weather. 'The wind flattened them against the ratlines; then, easing a
little, would let them ascend a couple of steps; and again, with a sudden
gust, pin all up the shrouds the whole crawling line in attitudes of
crucifixion.' (*The Nigger of the 'Narcissus'*)

Back in England, Conrad continued to work on his novel, and to seek another post. He asked his aunt to use her influence to get him a job as a Suez Canal pilot; in another letter he speaks of a job in the pearl fisheries off the Australian coast. In December, he found what was to be his last berth on a ship when he signed as first officer of the *Adowa*. At Rouen the *Adowa* waited for emigrants for Canada, but in January her voyage was cancelled, and Conrad returned to London.

He had been there only a month when news of his uncle's death reached him from Poland: 'I am a little like a wild animal; I try to hide myself when I am suffering in body or mind, and right now I am suffering in both', he wrote.

It seems now a strange coincidence that the desultory ending of Conrad's career as a seaman should take place at the time of his uncle's death, but the lack of another job and the need to distract his thoughts from the loss of his closest adviser and friend appears to have turned him to his writing. During April, he finished Chapter XI of his novel while staying at Elstree with Edward Sanderson. On April 24 he wrote to Marguerite Poradowska: 'It is my sorrowful duty to inform you of the death of Mr Kaspar Almayer, which occurred this morning at three o'clock.' The manuscript was sent off in July to the publishing house of Fisher Unwin. We know, from a letter he wrote, that, in preparation for its possible rejection, the manuscript was 'enclosed in brown paper addressed to J. Conrad, 17 Gillingham St., s.w. and franked, for return by parcel post, by twelve 1d stamps. The brown paper package was put between two detached sheets of card-board secured together by a string.'

Conrad now endured three months of extreme anxiety over his novel. 'My nervous disorder torments me, makes me miserable and paralyses action,' he wrote, and late in July he complained to his aunt, 'This may go on for months, and in the end, I don't think they will accept it.' Then he conceived the idea that the novel might be published jointly by himself and his aunt, and that he would use the pseudonym 'Kamondi', which in Malay means 'rudder': 'The name "Kamondi" in small letters somewhere will suffice. Let your name appear on the title-page.'

In September he was demanding the return of his novel, and then, on 4 October 1894, Fisher Unwin accepted it for publication. Conrad wrote to his aunt that Fisher Unwin had offered him £20 for the copyright. Conrad's days as a seaman were over. Although he still, for a time, looked for another berth, the acceptance of *Almayer's Folly* formed a watershed in his life and brought about another change of role. The nervousness and suspicion of this 'Polish gentleman cased in British tar' at the commencement of his new career come out in his reaction on meeting his publishers: 'at first the two "readers" of the firm . . . complimented me effusively (were they by any chance making

Edward Garnett with his son David in 1897. It was in October 1894 that Garnett, one of the readers for Fisher Unwin, advised the acceptance of Conrad's first novel, *Almayer's Folly*. Garnett's support for Conrad and his critical appreciation of his work was to outlast the writer's life.

fun of me?).' But one of those readers, W. H. Chesson, was to recall 'how the magical melancholy of that masterpiece [*Almayer's Folly*] submerged me and how its note of haunted loneliness called me into isolation, while I read it in the clamorous heart of London.' The other reader was Edward Garnett, whose mission was 'to discover the genius and fight for his recognition'. He discovered John Galsworthy, D. H. Lawrence, W. H. Davies, W. H. Hudson and H. E. Bates, and he was to be for a long time Conrad's friend and adviser. He described Conrad's appearance at that first meeting:

My memory is of seeing a dark-haired man, short but extremely graceful in his nervous gestures, with brilliant eyes, now narrowed and penetrating, now soft and warm,

Conrad and H. G. Wells together. Their friendship resulted from Wells' review of *An Outcast of the Islands* in 1896. Conrad wrote at the time, 'he descended from his "Time, Machine" to be kind as he knew how'.

with a manner alert yet caressing, whose speech was ingratiating, guarded, and brusque turn by turn. I had never seen before a man so masculinely keen yet so femininely sensitive. . . . Conrad, extremely polite, grew nervously brusque . . . and kept shifting his feet one over the other, so that I became fascinated in watching the flash of his pointed, patent leather shoes.

Conrad's new occupation did not fundamentally alter his nature and outlook. 'His whole attitude of life was opposed to any idea of rest; he gave the impression of continual restlessness,' his wife wrote later, and a friend said, 'one always felt that there was a depth within him that even after years of the closest friendship, one had not reached.' Externally, Conrad's life changed to the extent that he married, had children, wrote his novels and made his home at various houses in southern England. His true existence was now buried within his imagination where his novels were created out of his past.

Conrad went on to write *An Outcast of the Islands*, dashing off to Switzerland to finish it, and on the publication of these first novels, *Almayer's Folly* in 1895 and *An Outcast of the Islands* in 1896, he was given a sympathetic reception by the critics, several of whom recog, nized the originality and genius of this new author. One of them was H. G. Wells, who reviewed the second book anonymously in the *Saturday Review* and to whom Conrad wrote, being delighted to learn his identity: 'I wrote to the reviewer. I did! And he wrote to me. He did!! And who do you think it is? – He lives in Woking. Guess. Can't tell? . . . It is H. G. Wells. May I be cremated alive like a miser, able moth if I suspected it!'

Some time between 1893 and 1894, Conrad met, through his friend G. F. W. Hope, a Miss Jessie George who was working as a 'typewriter' in the city. Their friendship developed, and early in 1895 he proposed to her. They had taken refuge from the terrible weather

in the National Gallery, Jessie Conrad recalled, and Conrad said suddenly, 'Look here, my dear, we had better get married and out of this. Look at the weather. We will get married at once and get over to France. How soon can you be ready? In a week – a fortnight?' He announced that he had not very long to live and had no intention of having children.

She did not see him again for three days, after which he returned and insisted on the marriage being within six weeks, when they would go abroad. To Karol Zagórski, his cousin in Poland, Conrad wrote humorously announcing the marriage: 'However, I am not frightened at all, for as you know, I am accustomed to an adventurous life and to facing terrible dangers . . . Jessie is her name; George her surname. She is small, not at all striking-looking person (to tell the truth, alas – rather plain!) who nevertheless is very dear to me. . . . There are nine children in the family. . . . However . . . I am not marrying the whole family.'

They were married on 24 March 1896 at the St George Register Office, Hanover Square, with Conrad's oldest friends in England, Hope and Krieger, as witnesses. On the certificate, Conrad gave his father's occupation as 'landowner'. A photograph of Jessie shows her as a plump attractive girl, who in later life, in part no doubt owing to the inactivity imposed on her, put on a great deal of weight. Conrad said he knew he was marrying quality, but he had been specially favoured because in a few years he had quantity as well.

Jessie Conrad's life with her husband was not altogether an easy one, or so her two books about him suggest, but with her placid and self-contained temperament, she was in some ways an ideal wife for a man of Conrad's genius and nature, a fact which she indicated in one of her two books on her husband: 'Indeed I owe much to my calm placid temperament, that was in the end such a sound foundation for

Jessie George in the year of her marriage to Conrad, 1896, and (*below*) Conrad's certificate of marriage.

When Married.	Name and Surname.	Age.	Condition.	Rank or Profession.	Residence at the time of Marriage.	Father's Name and Surname.	Rank or Profession of Father.
Twenty fourth March	Joseph Conrad Korzeniowski	38 years	Bachelor	Master Mariner	17 Gillingham Street Pimlico	Joseph Theodore apollonius Korzeniowski (deceased)	Landowner
1896	Jessie George	22 years	Spinster		14 Lyden Grove Peckham	Alfred Henry George (deceased)	Bookseller

96. Marriage solemnized at *The Register Office* in the *District* of *St George Hanover Square* in the County of *London*

d in the *Register Office* according to the Rites and Ceremonies of the ———— by Certificate *before* me,

Married solemnized on us, { Joseph Conrad Korzeniowski / Jessie George } in the Presence of us, { G. F. W. Hope / Jane George / A. Phil Krieger } H. G. Holland Registrar / Thomas Worlock Superintendent Registrar

71

our future understanding.' According to her son Borys, 'Complete imperturbability and apparent lack of emotion under any circumstances, in spite of her almost constant pain and physical discomfort, remained with her throughout her life. This unassailable placidity was almost frightening at times.'

After a stormy night-crossing of the Channel on the day they married they did not reach their hotel in St Malo until three p.m. – too late for dinner. Conrad did not order food but took his wife out for a walk. At half past four they stopped at a café and were served weak tea and four hard biscuits: 'Then [Jessie recalled] I broke out. My fortitude gave way. I declared I was dying for something serious to eat. I reminded him that I had had nothing to eat since dinner the day before.' In spite of this, she did not eat until six p.m.!

They spent the first months of their married life on the rocky and barren Île-Grande near Lannion, Brittany, where Conrad began *The Rescuer*, later to be called *The Rescue*, and *The Nigger of the 'Narcissus'* and wrote some short stories. Jessie Conrad immediately took on her duties as typist for him, and she recalls her first experience of Conrad's recurrent bouts of illness: 'To see him lying in the white canopied bed, dark-faced, with gleaming teeth and shining eyes, was sufficiently alarming, but to hear him muttering to himself a strange tongue (he must have been speaking Polish), to be unable to penetrate the clouded mind or catch one intelligible word, was for a young, inexperienced girl truly awful.'

Conrad clearly loved the island: 'As rocky and barren an island as the heart of (right-thinking) men would wish to have.' It was inhabited by women 'black-clad and white-capped' – the men were elsewhere fishing and only 'a few old old fellows forgotten by the capricious death that dwells upon the sea shuffle about amongst the stones of this sterile land.' It was here that Conrad wrote the macabre *An Outpost of Progress* (a story set in the Congo), the painful *Idiots*, and the gentle Malay story *Lagoon*, which he himself described as having 'lots of second-hand Conradese in it'. He struggled ineffectively with *The Rescuer*. To Garnett he wrote: 'I have been rather ill. Lots of pain, fever, etc. etc. The left hand is useless still. This month I have done nothing to the *Rescuer* – but have about seventy pages of rotten twaddle.' But Garnett, after reading this beginning, wrote back: 'Excellent, oh Conrad, Excellent. I have read every word of the *Rescuer* and think you have struck a new note. . . .' Unfortunately, it was to be twenty-three years before Conrad succeeded in completing this novel. 'I have long fits of depression,' he wrote at this time, 'that in a lunatic asylum would be called madness.' And as a final blow, he learnt that both he and his friend Hope had lost money in a South African gold-mining venture. A visitor to the island who remarked, 'the winter in that house, exposed to the four winds of heaven, was

scarcely an ideal spot for anyone subject to sudden illness' had the effect of bringing Conrad and Jessie back to England once more.

Thus, in these early months of marriage, Conrad's pattern was established – difficulties in writing, bouts of crippling malarial gout and fever, fits of depression, financial difficulties, and frequent dashes to the Continent for relief.

The Conrads lived at first near their friends the Hopes at Stanford-le-Hope, Essex, in a house Conrad called 'a damned jerry-built rabbit hutch'. Here Conrad finished *The Nigger of the 'Narcissus'*, towards the end writing to Garnett: 'I can't eat – I dream – nightmares – and scare my wife. I wish it was over!' But the struggle was worth while. The novel, accepted by W. E. Henley for the *New Review* and published in book form in 1897, received what Garnett called 'a general blast of eulogy from a dozen impressive sources', and it can be seen as marking the end of Conrad's apprenticeship as a writer.

In March 1897, the Conrads moved to an Elizabethan farmhouse, Ivy Walls, not far from their first home. Jessie wrote: 'It was some time

A letter from Conrad to Edward Garnett, dated 9 April 1896, from Île-Grande, Lannion.

(*Left*) Ivy Walls, in Essex, where the Conrads lived from March 1897 to October 1898.

(*Right*) G. F. W. Hope, one of Conrad's earliest friends in England, a former seaman and later a director of companies, who appears in *Heart of Darkness*.

(*Far right*) the yawl *Nellie*, owned by G. F. W. Hope. The *Nellie* figures in *Heart of Darkness*.

before it dawned on me that he must be feeling the isolation from men of his own standard of intellect. The only man near at hand was dear Mr Hope. . . . Then the persistent attacks of gout interfering with the only form of recreation I knew appealed to him. Every Sunday he was well enough we would take a picnic lunch and join Mr Hope in a boating expedition.' Writing of those days, his friend Hope recalled their provisions: 'we went aboard the *Nellie* [Hope's yawl] taking with us, a cold leg of lamb, and a bottle of mint-sauce (we always started our cruises with a leg of lamb), some bottles of Reffels Beer.' On one occasion, along with two other friends of Hope, they had sailed as far as Margate, and they 'played cards till time to turn in'. Naturally, on these occasions, there was a great deal of 'yarning' about their former adventures and seafaring experiences, since the party was generally made up of men who had followed the sea. *Heart of Darkness* begins with what must have been a very typical scene on the *Nellie*: 'The *Nellie*, a cruising yawl, swung to her anchor without a flutter of the sails, and was at rest. . . . The sea-reach of the Thames stretched before us like the beginning of an interminable waterway.'

Conrad went on to write *Youth*, which was sent to William Blackwood, publisher of *Blackwood's Magazine*, in June 1898, and he began a short story called *Jim* which was to grow into the novel *Lord Jim*. And all the time he was struggling with *The Rescuer*: '*The Rescuer: A Romance of Shallow Waters*, spreads itself, more and more shallow, over innumerable pages.' 'Pages accumulate,' he wrote to Garnett, 'and the story stands still. I feel suicidal.' 'The effort I put out should give birth to Masterpieces as big as Mountains – and it brings forth a

ridiculous mouse now and then.' Perhaps it was these difficulties that made him, that year particularly, regret giving up the sea: 'Last night a heavy gale was blowing and I lay awake thinking that I would give ever so much . . . for being at sea, the soul of some patient faithful ship standing up to it, under lower topsails and no land anywhere within a thousand miles.' He was at times desperate: 'I am appalled at the absurdity of my situation – at the folly of my hopes, at the blindness that had kept me up in my gropings. Most appalled to feel that all the doors behind me are shut and that I must remain where I had come blundering in the dark.' He was under the constant pressure of having to live on what he could earn as a writer, and this pressure must have increased with the knowledge, in July 1897, that Jessie was pregnant – 'I am not unduly elated,' he wrote to Edward Sanderson.

But in terms of congenial companionship, life was improving for Conrad. Edward Garnett, John Galsworthy and Edward Sanderson visited him, and the publication of *An Outpost of Progress* (1897) brought about a lifelong friendship with Robert Bontine Cunning-hame Graham, the adventurous and romantic descendant of King Robert II of Scotland, who also had Spanish and Italian blood in his veins. Graham had spent eight years in South America, ranching and living with gauchos, and had prospected for gold in Spain. He was at one time an MP (Liberal), involved in the Bloody Sunday demon-stration in Trafalgar Square with William Morris, Bernard Shaw, Mrs Annie Besant and Prince Kropotkin. Conrad and Cunning-hame Graham had this in common – they were both adventurers, they had both wandered over great parts of the globe, both were

William Blackwood, the Edinburgh publisher and editor of *Blackwood's Magazine* which published in serial form among other works of Conrad *Lord Jim* and *Heart of Darkness*. In 1899, Conrad wrote: '*Blackwood's* is the only periodical *always* open to me – and is the only one for which I care to work.'

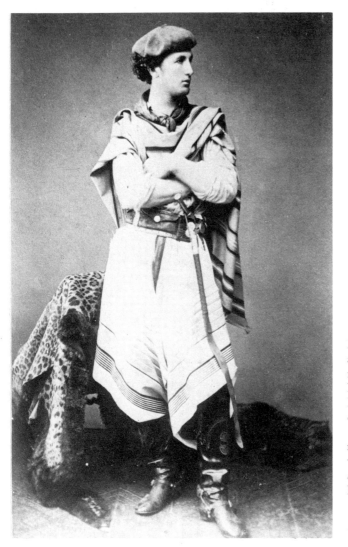

R.B. Cunninghame Graham dressed as a gaucho, probably soon after his return from South America in the late 1870s. Conrad's friendship with him lasted from 1897 until Conrad's death in 1924. In a letter to Graham in 1920 Conrad wrote: 'May you ride firm as ever in the saddle, to the very last moment, *et la lance toujours en arrêt*, against The Enemy whom you have defied all your life!'

(*Right*) photograph of Conrad given by him to Cunninghame Graham.

courageous journeyers. But politically they were far apart. Cunninghame Graham held extreme revolutionary views: 'Parliament is a ship of fools. . . . Surely it is getting almost time to take to boarding pikes . . . and capture it'; whereas Conrad was profoundly conservative, and saw in Anarchism 'the criminal futility of the whole thing, doctrine, action, mentality; . . . the contemptible aspect of the half crazy pose as of a brazen cheat exploiting the poignant miseries and passionate credulities of a mankind always so tragically eager for self destruction.'

Stephen Crane, author of *The Red Badge of Courage*, a book with a rigorously honest attitude to war, had first met Conrad when Sidney Pawling, of the publishers Heinemann, took them both to lunch in

With affectionate
regard
Jph Conrad
1903

Ford Madox Hue[f]
[h]ovel[ist]
Ford Madox

(*Left*) Stephen Crane in 1899, four years after the publication of his famous novel of the American Civil War, *The Red Badge of Courage*.

Ford Madox Hueffer (Ford Madox Ford). He collaborated with Conrad in writing *The Inheritors* (1901) and *Romance* (1903). Ford himself claimed to have greatly influenced Conrad's work.

October 1897. Afterwards the two tramped the streets of London together and early in December 1897 Crane stayed with the Conrads: 'I had Crane here last Sunday. We talked and smoked half the night.' The relationship between Cunninghame Graham and Conrad was between equals and ended only with Conrad's death in 1924: that between the young American writer (already tubercular and with only two years to live) and Conrad was that of an admiring son and a father. Garnett recalls a visit to Crane's home on one occasion when Conrad was there:

I saw him with Stephen Crane [and] he was delightfully sunny, and bantered 'poor Steve' in the gentlest, most affectionate style, while the latter sat silent, Indian-like, turning inquiring eyes under his chiselled brow, now and then jumping up suddenly and confiding some new project with intensely electric feeling. . . . And Conrad's sceptical answers were couched in the tenderest, most reluctant tone. I can still hear the shades of Crane's poignant friendliness in his cry 'Joseph!' and Conrad's delight in Crane's personality glowed in the shining warmth of his brown eyes.

In September 1898, while staying with Edward Garnett, Conrad met Ford Madox Ford and seven years later such was the strength of their

78

friendship that he was able to write to H. G. Wells: 'As to Ford he is a sort of lifelong habit.'

Ford Madox Ford (originally Hueffer), son of a famous music critic and related to both Ford Madox Brown, the painter, and William Michael Rossetti, was then twenty-four and already publishing. Wells described Ford as 'a long blonde with a drawling manner. . . . What he is really or if he is really, nobody knows now and he least of all; he has become a great system of assumed personas and dramatised selves.'

Ford suggested that the Conrads should rent from him Pent Farm, an old farmhouse at Stanford, near Hythe in south-west Kent, and as Conrad liked it immediately, they moved in at the beginning of autumn.

Pent Farm was their home from 1898 until 1907. It was remote, but by chance it was 'at the very heart of English literary life of that

Pent Farm, near Hythe in south-west Kent. Conrad lived here from 1898 to 1907, a period when he wrote some of his best works.

Henry James at Brede Place, the home of Stephen Crane, in 1899.

period'. Henry James lived at Rye. He and Conrad were foreigners, both extremely courteous in manner, they spoke French for preference and Conrad addressed James as 'mon cher Maître'. H. G. Wells lived at Sandgate and Rudyard Kipling at Rottingdean. Wells and Conrad were totally different characters, and their friendship was never a close one. Wells wrote:

At first he impressed me . . . as the strangest of creatures. He was rather short and round-shouldered with his head as it were sunk into his body. He had a dark retreating face with a very carefully trimmed and pointed beard, a trouble-wrinkled forehead and very troubled dark eyes, and the gestures of his hands and arms were from the shoulders and very Oriental indeed. . . . He spoke English strangely . . . he would supplement his vocabulary . . . with French words . . . he had . . . acquired an incurable tendency to pronounce the last 'e' in these and those. He would say, '*Wat*

H. G. Wells (*above*) and Rudyard Kipling. Conrad wrote to Cunning‚ hame Graham in 1897, 'Some of his [Kipling's] work is of impeccable form and because of that little thing he shall sojourn in Hell only a very short while.'

shall we do with *thesa* things?' . . . 'My dear Wells, what is this *Love and Mr Lewisham about*?' he would ask. But then he would ask also . . . 'What is all this about Jane Austen? What is there *in* her? What is it all *about*?'

Wells also tells an amusing story of Conrad's first encounter with Shaw:

When Conrad first met Shaw in my house, Shaw talked with his customary freedoms. 'You know, my dear fellow, your books won't *do*' . . . and so forth.

I went out of the room and suddenly found Conrad on my heels, swift and white‚faced. 'Does that man want to *insult* me?' he demanded.

The provocation to say 'Yes' and assist at the subsequent duel was very great, but I overcame it.

Conrad himself wrote to Garnett: 'Four or five months ago G.B.S. towed by Wells came to see me reluctantly and I nearly bit him.'

Conrad's wife, Jessie, and elder son,
Borys, at Pent Farm, 1900.

In spite of Conrad's ultimatum that there should be no children,
two sons were born, Borys in 1898, and John in 1906. Conrad's
attitude to their arrival and to his wife throws some interesting light
on his character. He was accustomed to sign himself, when he wrote
to her, 'your property' and 'your boy', and he appears to have been,
initially, a little jealous of his sons. Jessie recalls that Conrad was
wandering in the garden when Borys was born, and when he heard a
child cry he shouted to the maid, 'Send that child away at once; it will
disturb Mrs Conrad!' 'It's your own child sir,' the girl answered

indignantly, and on his mother-in-law coming to announce the birth, 'he managed to conceal [his feelings] beneath an air of detached interest.' On the same day, he added a postscript to a letter to Cunning-hame Graham: 'This letter misses this morning's post because an infant of male persuasion arrived and made such a row that I could not hear the postman's whistle.' He told Garnett, 'I hate babies', and when later the Conrads travelled by train to stay with the Cranes, Conrad 'laid down the law' to the effect that although they would travel in the same carriage 'on no account were we [his wife and her sister] to give any indication that he belonged to [their] little party.' Conrad 'seated himself in a far corner, ostentatiously concealing himself behind a newspaper.' The baby's continued crying brought him sympathy, as being the only man there, from the other passengers, until Jessie's younger sister turned to him and asked him to get the baby's bottle from the suitcase above his head.

The household at Pent Farm centred about Conrad who was never to be disturbed when he was writing. He would work at odd hours as the inspiration occurred, often throughout the night. He was irascible, at times, and eccentric and his temper was unpredictable. Jessie describes how, while collaborating with Ford, Conrad, on one occasion,

stalked through the dining room with the terse request that I should at once prepare him a dose of gout medicine. He then announced to all and sundry his intention of retiring to the next room and trying to rest. He wished to be alone there. . . . Totally disregarding his guests, who looked . . . uncomfortable, he closed one door after another behind him with considerable violence. . . . [Later] he reappeared refreshed after his nap, and quite ready to make himself agreeable, both his irritation and threatened gout gone.

He also had the habit 'of making bread pellets and flinging them about the room. . . . I have seen them fly into the soup-plates and glasses of our guests. The more excited or irritated he got, the quicker flew the missiles, and those in the line of fire would look apprehensively at their host.' One evening, suspecting there was an intruder in the garden, he dashed outside with his rifle, and having as he thought run the in-truder to earth in the outside lavatory, burst into the building, shouting, 'Come out you – Damn you!' It was his mother-in-law, who never again visited them. In spite of constant shortage of money, he was one of the first in England to run a car, which he drove furiously, always wearing his grey bowler hat and havelock, with his monocle in his eye.

A photograph of Jessie Conrad used by her as a greetings card, Christmas 1926.

It has been remarked upon by several people, including his son Borys, that however emotional Conrad might become over trifles he had 'complete composure and competence when confronted with a real emergency.'

Early in 1899, Conrad received a boost to his morale. The *Academy* 'crowned' his *Tales of Unrest* (1898), selecting one of the stories in the

Joseph Conrad, his son John and a
friend, Jane Anderson Taylor, 1916.

The first long motor trip to visit
Conrad's friends the Hopes: Joseph
Conrad, Conrad Hope, Borys
Conrad and Jessie.

collection, *Karain*, for special praise and awarding Conrad 50 guineas.
Triumphant and full of fun Conrad wrote to Edward Garnett on
13 January 1899:

Have you seen *it*! *It!* The Academy. When I opened the letter I thought it was a
mistake. But it was too true, alas. I've lost the last ounce of respect for my art. I am lost
– gone gone – done for – for the consideration of 50 gns.

In terms of his art, the years at Pent Farm were the most fruitful for
Conrad, though his wife was probably right in seeing them as falling

into two periods. The first, which Conrad called his 'Blackwood' period, covered four years. During this time his health was comparatively sound, he was on good terms with William Blackwood, his stories appearing frequently in *Blackwood's Magazine*, and his work was well received. *Lord Jim* (1900), the *Youth* volume (1902) containing *Youth*, *Heart of Darkness* and *The End of the Tether*, and the *Typhoon* volume (1903), were written at this time, and Conrad collaborated with Ford on *The Inheritors* (1901) and *Romance* (1903).

From time to time, he stayed for a few days in London where he would lunch with Edward Garnett, W. H. Hudson, E. V. Lucas, Stephen Reynolds, Edward Thomas or Perceval Gibbon at the Mont Blanc restaurant in Gerrard Street, or meet (Sir) Hugh Clifford, (Sir) Edmund Gosse or (Sir) Frank Swettenham at the Wellington Club.

The change to less fortunate circumstances came with the publication of *Typhoon* in 1903, when the literary agent, J. B. Pinker, took over the handling of Conrad's business affairs. Agents were comparatively new arrivals on the literary scene, and in spite of the fact that Pinker was extremely useful to Conrad, particularly in advancing him sums of money when he was in need, his intervention seems to have harmed Conrad's good relationship with the publisher Blackwood.

J. B. Pinker and Conrad at Pinker's home, 1922. Pinker approached Conrad in 1899 and later acted as his literary agent until Pinker's death in the year this photograph was taken. Pinker was agent for many leading writers of the day. When he recognized talent he was generous with his financial aid, as Conrad and Arnold Bennett knew from experience.

(*Left*) Sir Henry Newbolt, who met Conrad while he was working on *Nostromo*.

A profile of Conrad, 1922.

Then Conrad exhausted himself over the 'intense creative effort' required for the writing of *Nostromo*, a novel which must have been initially inspired by Cunninghame Graham and his knowledge of South America, and which was to set out Conrad's vision of a 'twilight country . . . with its high shadowy Sierra and its misty Campo for mute witnesses of events flowing from the passions of men shortsighted in good and evil.' He could, without exaggeration, say 'for twenty months, neglecting the common joys of life that fall to the lot of the humblest on this earth, I had, like the prophet of old, "Wrestled with the Lord" for my creation.' The strains within his personality set up by his creative sensibility are well indicated by Sir Henry Newbolt, who met Conrad while he was working on *Nostromo* at the Saville Club, then housed in Piccadilly:

The man himself did not disappoint me. One thing struck me at once, the extraordinary difference between his expression in profile and when looked at full face. In both aspects it was an oriental face: but while the profile was aquiline and commanding, in the front view the broad brow, wide-apart eyes and full lips produced the effect of an intellectual calm and even at times of a dreaming philosophy. Then came a sharp surprise. As we sat in our little half-circle round the fire, and talked on anything and everything, I saw a third Conrad emerge – an artistic self, sensitive and restless to the last degree. The more he talked the more quickly he consumed his

86

cigarettes, rolling them so fast one after another that the fingers of both hands were stained a deep yellow almost as far as the palms. And presently, when I asked him why he was leaving London after a stay of only two days, he replied that he could never be more than a day or two in London, because the crowd in the streets so terrified him. 'Terrified? – by that dull stream of obliterated faces?' He leaned forward with both hands raised and clenched. 'Yes, terrified: I see their personalities all leaping out at me like *tigers*!' He acted the tiger well enough almost to terrify his hearers: but the moment after he was talking again wisely and soberly as if he were an average Englishman with not an irritable nerve in his body.

Unfortunately, in spite of his intense effort, *Nostromo* (1904) did not receive the critical acclaim Conrad had hoped for. It was, he said, with the public 'the blackest possible frost'.

The last page of the first draft of *Nostromo*, 30 August 1904.

It is made payable
at Pinker's office
because I've no
banker after Watson's
failure. Two fifty
gone in one fell
swoop. I am
nearly out of
my mind with
worry and over-
work. My nerves
are all to pieces.
On top of all that
my wife had a
nasty fall in the street
and wrenched both
her knee-caps. There
was an awful
business with doctors
nurses, massage

His health began to deteriorate during the writing of this novel,
and then, in January 1904, Jessie injured her knees in a fall and was to
remain a semi-cripple for the rest of her life.

Matters did not improve for the Conrads. Conrad's bankers,
Watson & Co., failed. To his friend Krieger, Conrad wrote: 'I've
no banker after Watson's failure. Two fifty gone in one fell swoop. I
am nearly out of my mind with worry and overwork. My nerves are all
to pieces.' In October 1904 Jessie had an operation, the first of many
on her knees, and they went off to the Continent, Jessie being swung
in a chair on to ships and into railway carriages. They went to Capri
where Conrad hoped to rest and to write, but it was to be one of their
typically disastrous trips. The nurse looking after Jessie became ill,
Conrad suffered from influenza, bronchitis, insomnia and nerves,
and could not tolerate the climate, and he was again short of money.
It was fortunate that, in the same year, through the influence of friends,
he was given a grant of £500 with the King's consent from a con-
fidential official fund.

On his return to England, he was involved in the production of
his one-act play, *One Day More*: 'I don't think I am a dramatist,' he
concluded, and he later wrote: 'I have a secret horror of all actors and
. . . actresses.'

During the year 1905 to 1906, Conrad was working on *The Mirror of the Sea* (recollections of his experiences as a sailor), on the novel called *Chance*, on several short stories, including *An Anarchist* and *The Informer* – later published in a collection of six stories, *A Set of Six* – and on *The Secret Agent* which he finished in November 1906. For the three latter works he turned to the sensational subject of anarchy, no doubt in part through Ford's connections with anarchists. Ford admitted to knowing 'a great many anarchists of the Goodge Street group, as well as a great many of the police who watched them.' He was also a cousin of Olive, Helen and Arthur Rossetti, the children of William Michael Rossetti, who in their teens (Helen was then twelve) had run an anarchist printing press in the basement of their aunt's home in St Edmund's Terrace, and produced *The Torch: A Revolutionary Journal of Anarchist Communism*. Helen Rossetti, who died only recently, recalled to me that she had met Conrad on two occasions, before the writing of *The Secret Agent* and his other stories about anarchists, and she certainly appears as the anarchist young lady in *The Informer*. For *The Secret Agent*, Conrad made use of newspaper accounts of an actual anarchist event of February 1894 which had been given much publicity. An anarchist, Martial Bourdin (personally known to Helen Rossetti), had attempted to blow up the Greenwich Observatory and had succeeded in destroying himself. It was thought that he had been led on by his brother-in-law, H.B. Samuels, editor of a notorious anarchist newspaper, author of 'perfectly atrocious schemes' for future outrages in England, exponent of 'Direct Action' *and*, privately thought to be, a police agent. The involvement of a secret agent in the event, suggested the theme of his novel to Conrad.

Helen Rossetti, the beautiful niece of Dante Gabriel Rossetti, who appears as the anarchist young lady in Conrad's story *The Informer*.

Sightseers at the scene of the Greenwich Park explosion in which the anarchist Martial Bourdin (*left*) blew himself up by accident near the Observatory in February 1894. The Observatory can be seen in the distance and a white cross marks the spot where Bourdin's body was found. This outrage was a major source for *The Secret Agent*.

John Conrad (*right*) with his play-
mate, Robin Douglas, son of the
author Norman Douglas.

On 2 August 1906, his second son, John, was born at the Gals-
worthy's London house in Addison Road, and after finishing *The
Secret Agent* in November Conrad, 'feeling seedy and horribly
depressed', took his family off to the Continent again, to Montpellier
and Geneva. The trip was again disastrous, with Borys suffering from
adenoids, measles, bronchitis and whooping-cough, and then
rheumatism of the ankles. In a state of desperation, Conrad revised
The Secret Agent. 'Jessie', he wrote, 'has been simply heroic.'

They returned home in the summer of 1907. 'No more trips abroad,'
Conrad wrote, 'I am sick of them', and he stayed in England for the
next seven years, but not in the same house. He decided he could no
longer live at Pent Farm, and in September 1907 the Conrads moved
house again. They were to move three times between 1907 and 1910,
to Someries in Bedfordshire for over a year, to Aldington in Kent, and

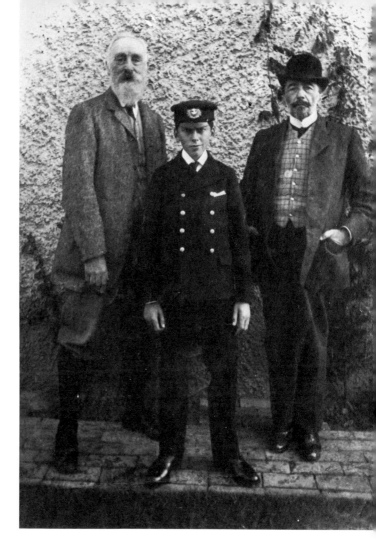

Joseph Conrad with his son Borys and Edmund
Oliver on the occasion of Borys' joining H M S
Worcester in 1911. Edmund Oliver was the owner
of Capel House.

Someries, Conrad's residence from September
1907 to March 1909. In the foreground is
Escamillo, Conrad's faithful dog. It was
Escamillo who shared with Conrad 'a piece of
cold chicken' at six o'clock in the morning after
a twenty-one-hour stint to complete *Lord Jim*.

Capel House and (*below*) the study, with Conrad's easy chair and writing table. This house was Conrad's residence from June 1910 to March 1919.

in 1910 to Capel House, an isolated farmhouse near Ashford. He came to loathe the Aldington house, but of Capel House he said: 'Yes, this place is all right. I can work here. We are surrounded by woods and the soil is clay, but the house is sympathetic.' At Capel House, friends continued to visit him – Warrington Dawson, the American journalist and writer, G. Jean-Aubry, his future biographer, Norman Douglas, Hugh Walpole and Arthur Marwood. Yet it is possible that his increased restlessness at this time was sympto-

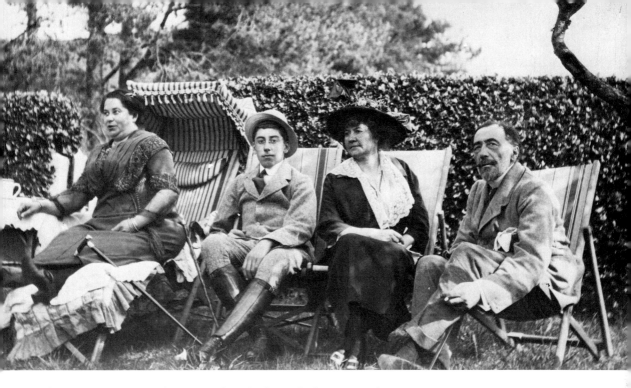

matic of the growing strain he was under which resulted in a complete breakdown in January 1910. At the time of the publication of *The Secret Agent*, the *T.P.'s Weekly* sent a reporter to interview Conrad and he commented:

He is abnormally highly-strung. He is sensitive, intensely susceptible to any slight jarring influences from outside. His nerves seem to be all on end. . . . He dislikes certain broad types of people virulently, and says so in a downright fashion. At such times he sloughs his elaborately courteous demeanour he reveals himself as a man of

Joseph Conrad, Jessie and Borys with Miss Ellen Glasgow, an American novelist, in the garden at Capel House, 1914, and (*below*) Joseph Conrad with Jessie and their son John in the study, 1915.

devastating force of character. He grows fierce, passionate, violent . . . triumphant and obliterating and sweeping away his carefully calculated suavity of speech.

In 1908 Conrad was fifty. As an author he had had great acclaim, but *Nostromo* and *The Secret Agent* had been disappointments, and he was oppressed by the fact that he was not a 'selling' author. He was tormented by the need to make money and the need to retain his artistic integrity. 'Ah! my dear,' he wrote to Galsworthy in 1908, 'you don't know what an inspiration-killing anxiety it is to think: "Is it saleable?" There's nothing more cruel than to be caught between one's impulse, one's act, and that question, which for me simply is a question of life and death.' In his fifty-first year, writing to a friend, Conrad declared with ironic bitterness: 'I have just received the accounts of all my publishers, from which I perceive that in all my immortal works (13 in all) have brought me last year something under five pounds in royalties.' At this time he was indebted to his literary agent, the gener-ous Pinker, to the extent of £1,500. Conrad fulminated against the reading public: 'Le public introuvable is only introuvable because it is all humanity. And no artist can give it what it wants because humanity does not know what it wants.' He attacked also the popular authors of the day, Grant Allen, Marie Corelli and Hall Caine: 'All three are very popular with the public – and they are also puffed in the press. There are no lasting qualities in their work. The thought is commonplace and the style without any distinction. They are popular because they express the common thought, and the common man is delighted to find himself in accord with people he supposes distin-guished.' Conrad had himself made a bid for popularity in choosing a sensational subject for *The Secret Agent*, but he was a difficult novelist whose complex methods of narration and use of broken time sequences, springing though they did from his need to present his individual vision, militated against popularity.

In 1902, William Blackwood had told Conrad that he was a loss to the firm – this after the sales of *Lord Jim*! – and it led Conrad to defend his artistic intention: 'I must not by any means be taken for a gifted loafer intent on living upon credulous publishers. Pardon this remark – but in a time when Sherlock Holmes looms so big I may be excused my little bit of self-assertion.' He wrote of his strict conception of his method of writing: 'And however unfavourably it may affect the business in hand I must confess that I shall not depart from my method. . . . All my endeavours shall be directed to understand it better, to develop its great possibilities, to acquire greater skill in the handling – to mastery in short.' Criticism of his 'method' only irritated him. To Galsworthy, who suggested that the play adapted from *The Secret Agent* might be cut, he retorted with bitter raillery: 'Indeed I have often felt that not only the Third but the Second Act could come

out altogether. After all: why the Professor? Why the Assistant Commissioner? Even Inspector Heat himself would be sufficiently characterized by his appearance in the Third Act . . . what is that old woman [Winnie Verloc's mother] doing there? She too could be eliminated: and also Mr Vladimir.' And taking up a critic's charge that his novel *Chance* could have been cut to half its present size, Conrad answered: 'No doubt that by selecting a certain method and taking great pains the whole story might have been written out on a cigarette paper.'

Under severe mental stress arising from these difficulties, and suffering from malarial gout, Conrad was nevertheless writing *Under Western Eyes* and *The Secret Sharer* (one of the famous stories in the collection *'Twixt Land and Sea*, 1912), collaborating on *The Nature of a Crime* with Ford, and composing his autobiographical *A Personal Record* for the *English Review* which Ford was now editing. In 1909 he quarrelled with Ford over this – 'His [Ford's] conduct is *impossible*. . . . He is a megalomaniac who imagines that he is managing the universe' – and they were never really reconciled. While Conrad was trying to complete *Under Western Eyes*, Pinker refused to advance more money unless he received more manuscript. 'You imagine how charming it is to be following the psychology of Mr Razumov under these conditions. It's like working in hell,' Conrad commented. He finished *Under Western Eyes* at the end of 1909, had a blazing row with his agent in London, and returned home to collapse, suffering a complete breakdown in health. His wife, writing to David S. Meldrum, reader for Blackwood, declared:

The novel is finished, but the penalty has to be paid. Months of nervous strain have ended in a complete nervous breakdown. Poor Conrad is very ill and Dr Hackney says it will be a long time before he is fit for anything requiring mental exertion. . . . There is the MS complete but uncorrected and his fierce refusal to let even I touch it. It lays on a table at the foot of his bed and he lives mixed up in the scenes and holds converse with the characters.

After an illness of three months, Conrad told Hugh Clifford, 'I begin to see the horrible nervous tension of the last two years . . . had to end in something of this sort', and to Norman Douglas he commented, 'I feel like a man returned from hell and look upon the very world of the living with dread.'

Perhaps, given Conrad's highly strung, pessimistic nature, and his deep absorption in his work, a breakdown would have been, under any circumstances, inevitable. His work exhausted him because he so completely immersed himself in his fictional world and its characters. He described being interrupted in the writing of *Nostromo* by a lady visitor and the shock to his nerves of being brought suddenly back from his imaginary South American republic: 'I jumped up

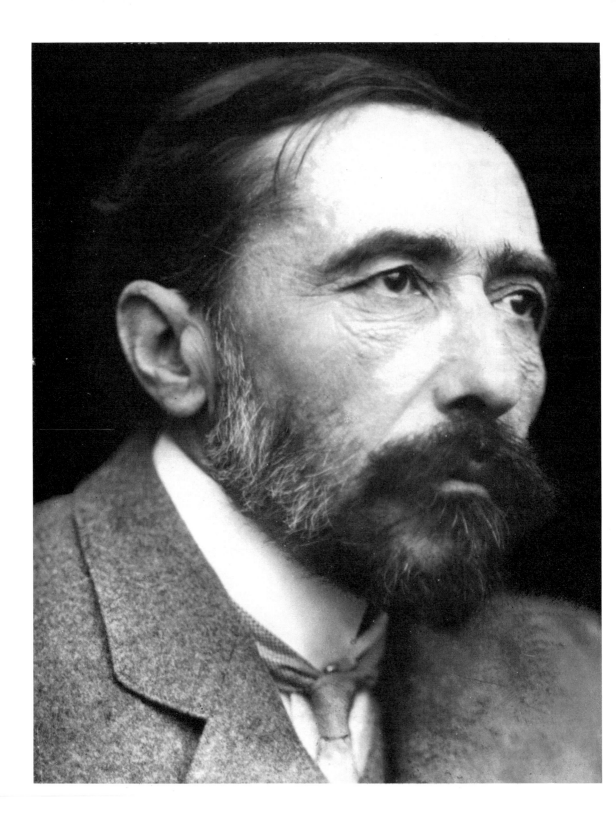

from my chair stunned and dazed, every nerve quivering with the pain of being uprooted out of one world and flung down into another – perfectly civil.' And he is probably not exaggerating when he spoke of writing his first novel: '... Almayer ... came nobly to the rescue. Before long, as only proper, his wife and daughter joined him round my table, and then the rest of that Pantai band came full of words and gestures. Unknown to my respectable landlady, it was my practice directly after my breakfast to hold animated receptions of Malays, Arabs and half-castes.' And Conrad knew the dangers of his behaviour: 'In that interior world where [the artist's] thought and his emotions go seeking for the experience of imagined adventures, there are no policemen, no law, no pressure of circumstances or dread of opinion to keep him within bounds.'

(*Opposite*) Conrad in 1904.

Conrad's pessimism as to mankind's condition was complete, and its influence in his work was again not conducive to popularity: 'What makes mankind tragic is not that they are the victims of nature, it is that they are conscious of it. To be part of the animal kingdom under the conditions of this earth is very well – but as soon as you know of your slavery the pain, the anger, the strife – the tragedy begins.' He graphically explained his view of the universe in a letter to Cunninghame Graham:

There is a – let us say – a machine. It evolved itself ... out of a chaos of scraps of iron and behold! – it knits. I am horrified at the horrible work and stand appalled. I feel it ought to embroider – but it goes on knitting. ... You cannot by any special lubrication make embroidery with a knitting machine. And the most withering thought is that the infamous thing has made itself; made itself without thought, without conscience, without foresight, without eyes, without heart. ... It knits us in and it knits us out. It has knitted time, space, pain, death, corruption, despair and all the illusions – and nothing matters. I'll admit however that to look at the remorseless process is sometimes amusing.

Not surprisingly, he did not sign petitions or write articles on the passing topics of the day. In his lack of reforming zeal and social conscience he differed from his friend Cunninghame Graham:

International fraternity may be an object to strive for and ... I will try to think it serious, but that illusion imposes by its size alone. Franchement what would you think of an attempt to promote fraternity amongst people living in the same street. I don't even mention two neighbouring streets. Two ends of the same street. There is already as much fraternity as there can be. ... What does fraternity mean? Abnegation – self-sacrifice means something. Fraternity means nothing unless the Cain-Abel business. That's your true fraternity.

And again:

The fate of a humanity condemned ultimately to perish from cold is not worth troubling about. ... If you believe in improvement you must weep, for the attained perfection must end in cold, darkness and silence. In a dispassionate view the ardour for reform, improvement for virtue, for knowledge, and even for beauty is only a vain

9

her at once under escort, direct" (underlined) "to the prison-hospital in Kiev, where she will be treated as her case demands."

"For God's sake, Mr. B., see that your sister goes away punctually on the day. Don't give me this work to do with a woman'—and with one of your family too. I simply cannot bear to think of it."

He was absolutely wringing his hands. My uncle looked at him in silence.

"Thank you for warning me. ~~but me~~ assure you that even if she were dying she would be carried out to the carriage."

"Yes—indeed—and what difference would it make—to Kiev or ~~over there~~. For she would have to go—And mind, Mr. B., I will be here on the day, not that I doubt your promise but because I must. I have got to. Duty. All the same my trade is ~~getting~~ not fit for a dog since some of you will persist in ~~making trouble~~ and all of you ~~Poles~~ have got to suffer for it."

This is the reason why he was ~~sitting~~ there in an open three-horse trap pulled up between the house and the great gates ~~to wait~~ ~~for our passage~~ I regret not being able to give up his name to the ~~pitying~~ scorn of all believers in the rights of conquest—a reprehensibly sensitive guardian of Imperial greatness. On the other hand, I am in a position to state the name of the Governor-General who signed the order with the marginal note "to be carried out to the letter" in his own handwriting. The gentleman's name was Bezak. A ~~great~~ dignitary, an energetic ~~ruler~~, the idol for a time of the Russian Patriotic Press.

· Each generation has its memories.

Corrected proof-sheet of *A Personal Record*, p. 66.

sticking up for appearances as though one were anxious about the cut of one's clothes in a community of blind men.

It is not surprising that Bertrand Russell (who met him first in September 1913) said of him, 'I felt . . . that he thought of civilized and morally tolerable human life as a dangerous walk on a thin crust of barely cooled lava which at any moment might break and let the unwary sink into fiery depths.' In *A Personal Record* (1912) Conrad writes, 'the aim of creation cannot be ethical at all. I would fondly believe that its object is purely spectacular. The rest is our affair, the human side of life is completely detached from the spectacular universe.' Conrad with prodigious courage had looked at the spectacular universe without blinkers, without the convictions which keep us safe and warm. After *Under Western Eyes*, he was never again to look so strenuously at the nature of the universe and the nature of man. From this time on, he seems often to be avoiding real problems, blurring the edges of his design, writing, almost, a parody of the real Conrad. He had had to work like a coal-miner in his pit quarrying all his 'English sentences out of a black night' and the struggle had to end sometime.

But his fortune was about to change. In 1911 he was given a Civil List Pension of £100, and in the following year an American lawyer, John Quinn, wrote offering to buy his manuscripts. But more important, he was then working on a novel he had started six years earlier and which was to be his first best-seller. The novel was *Chance* (1913). As I have suggested, Conrad was no longer producing the quality of work he had previously produced, and *Chance* is not his best, but neither is it more obviously 'popular'. Indeed, it is difficult to know precisely why this novel sold as it did. Conrad was unashamedly seeking popularity, and rewrote the end of the novel to make it 'nicer'. Garnett held the view that 'it is probable that the figure of the lady on the "jacket" of *Chance* did more to bring the novel into favour than a long review by Sir Sidney Colvin in *The Observer*.' But it was Sir Hugh Clifford who persuaded the proprietor of the *New York Herald* to take an interest in Conrad's work, and it was here that *Chance* was serialized. This had the effect of making a young man called Alfred Knopf, who worked for the publishers Doubleday, persuade his employers to put the full weight of promotion behind Conrad's book. It was a best-seller on both sides of the Atlantic.

At this time Conrad met Richard Curle, a young man with whom he was to form a firm and lasting friendship and who was to write

Note in the copy of *Almayer's Folly* belonging to Richard Curle, a close friend of Conrad.

The Gorka Narodowa estate
(property of Stefan Buszczyński,
originally Conrad's guardian), near
Cracow, which Conrad visited in
1914.

many books about him. Curle had already written a study of *Nostromo*,
and so was known to Conrad when they met for the first time at the
Mont Blanc restaurant in Gerrard Street, regular meeting-place of
groups of literary men. Conrad invited Curle down to Capel House,
an invitation Curle took up in December 1912.

In May of 1912, Conrad, having finished *Chance*, began a short
story which ultimately grew into a novel. *Victory* was completed by the
end of June 1914. Conrad's hero here is Axel Heyst, an extraordinarily
reticent man living in the tropics, whose philosophical father had in-
stilled in him one command in face of a distrust of mankind: 'Look on
– make no sound.' Pinker, thanks to the immense success of *Chance*,

The Hotel Pod Róza, Cracow, where Conrad stayed in 1914. The war caught up with Conrad here and, from this hotel, he wrote: 'The trains will run for the civil population for three days more: but with Jessie as crippled as she is and Jack not at all well (temperature) I simply dare not venture on the horrors of a war-exodus.'

was able to sell the serial rights of *Victory* for £1,000 and on the strength of his new financial success, Conrad planned a trip to Poland.

'I was pleased,' wrote Conrad, '... to visit the town where I was at school before the boys by my side should grow too old, and gaining an individual past of their own, should lose their unsophisticated interest in mine,' and they started from Harwich on 25 July 1914. Following the tradition of their wanderings abroad, the visit had a strong element of disaster. In Cracow, Conrad went over the ground that had brought many poignant memories of his boyhood – the Florian Gate, St Mary's Church, the University – and he recalled walking in the city with Borys at night, and an 'unassuming (but

armed) policeman' turning his head 'to look at the grizzled foreigner holding forth in a strange tongue to a youth on whose arm he leaned.' Borys describes his father's unexpected meeting with an old friend:

I suddenly became aware of my Father sitting quite rigid, with his fork half-way to his mouth, staring across the room towards the door . . . the picture which remains in my memory is of a tall handsome man . . . standing motionless in the doorway and staring with equal intensity . . . my Father . . . leaping to his feet with a shout of 'Kostoosh!' rushed towards the door. His opposite number in the doorway . . . burst into violent motion at the same time, and they met and embraced in the middle of the big room.

'I understood my husband so much better after those months in Poland,' Jessie wrote. 'So many characteristics that had been strange and unfathomable before, took, as it were, their right proportions. I understood that his temperament was that of his countrymen.' Then, while they were visiting a country house, their hostess came in and said that the soldiers were taking horses from the ploughs and the carts in the fields: Austria-Hungary declared war on Serbia in July, and on 1 August, Germany declared war on Russia and then invaded France. The First World War had begun. The Conrads took refuge with a relative who had a house in the Carpathians, but in early October Conrad decided they must try to get home:

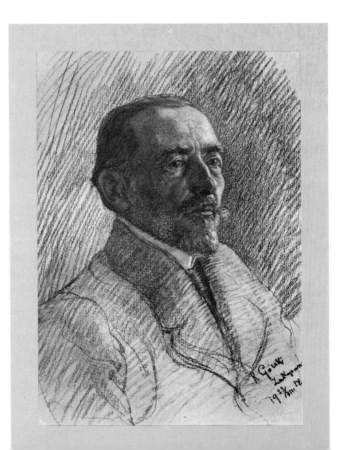

Drawing of Conrad by K. Gorski done at Zakopané, Poland.

Villa Konstantynowka (home of a Polish relative, Mrs Zagórska) at Zakopané, a resort in the Carpathians. On 1 August 1914 Conrad wrote to Galsworthy from his hotel in Cracow: 'I have decided to take myself and all the unlucky tribe to Zakopané (in the mountains, about 4 hours by rail from here).'

(*Left*) John Conrad, photographed at Zakopané in 1914, and Borys Conrad with his mother, photographed in the same year.

So we started suddenly, at one in the morning, on 7 October in a snowstorm in an open conveyance of sorts to drive thirty miles to a small railway station where there was a chance of finding something better than a horse-truck to travel in with *ma petite famille*. From there to Cracow, some fifty miles, we sat eighteen hours in a train smelling of disinfectants and resounding with groans. In Cracow we spent untold hours sitting in the restaurant by the railway station, waiting for room in some train bound to Vienna.

They stayed in Vienna five days, since Conrad had gout. From Milan he cabled Pinker for money. They reached England on 3 November. Jessie commented, 'We had had a narrow escape.'

Borys Conrad joined the army and he has described his last brief visit home before he went to war:

I arrived in the small hours of the morning and tapped on the study window where a light was still burning. J. C. accepted my arrival quite calmly but, having ... been told the true facts, screwed his monocle into his eye and treated me to the most savage glare I ever remember; then ... he said, 'Go up to your Mother for five minutes then come down to me, you must be under way again in an hour.' When I rejoined him he said: 'Look here, Boy, in case you should get yourself "knocked on the head" out there, I should at least like to know where your remains are disposed of.' He then explained a code he had devised by means of which I could let him know approximately what part of the front I was on, without running foul of the censor.

An inscribed photograph of Conrad on HMS *Ready* at sea, November 1916.

HMS. Ready. (Spᵃˡ Serᶜᵉ)
North Sea. 1916.

Evening of October. 1916.
barehooded: H.J. Osborn lieut R.N.R.

light northerly wind, J.C at
the wheel luffing-up the Ready
close to the wind to bring
Flamboro' Head on the
port bow. distce 20 miles (about).
2ᵈ Nov. 1916.

Joseph Conrad in later years.

Borys comments that 'Although very emotional, he kept his feelings rigidly under control on this occasion.'

Conrad produced little during the war, though he did write *The Shadow-Line* in 1915, which was dedicated to Borys. But he no longer needed to write for money – in 1917, although he published little he had an income of £2,000. He wanted to take some active part in the war, and in September 1916 he was involved in an Admiralty scheme to observe activities in various British ports. He flew from the Royal Naval Air Station at Yarmouth, and on 18 November he wrote 'at sea by patrol boat' to Pinker:

> All well
> Been practice-firing in sight of coast
> Weather improved
> Health good
> Hopes of bagging Fritz high
> Don't expect to hear from me for ten days.

After this, he was interested in the dramatization of *Victory* being carried out by Macdonald Hastings, and began to write *The Arrow of Gold* which was published in 1919. *The Arrow of Gold* deals in part with Conrad's own experiences in Marseilles (to what extent and with what accuracy is still not known) though Conrad himself could not read the proofs without 'a slight tightness of the chest'. He also spoke of his work here as 'the thinnest possible squeaky

Oswalds, Bishopsbourne, near Canterbury. This was
Conrad's last home, where he lived from 1919.

Joseph Conrad with Carola and Angela Zagórska (then
his nearest living Polish relations) on the window-ledge
of his study at Oswalds, *c.* 1921–22.

bubble' and, alas, it is only too true an assessment. Jessie's knee again necessitated a series of operations, and Borys was gassed and shell-shocked in October 1918. At the end of the war, Conrad saw no hope for the future 'in all this babel of League of Nations', and was shocked that the Bolsheviks were invited to send delegates to the Peace Conference.

In 1919 he succeeded in finishing *The Rescue*, the novel he began on his honeymoon twenty-three years earlier. In October they moved to Oswalds, a Georgian house at Bishopsbourne, near Canterbury, which was to be Conrad's last home. Jessie was having more trouble with her knee and had another operation, this time in Liverpool, and then two more operations the following year. They were compara-tively wealthy – film rights for his books brought in about £4,000 – yet Conrad was still in difficulties: 'I am spending more than I ought to – and I am constitutionally unable to put on the brake unless in such a manner as to smash everything!' and he considered living

Conrad with Sir David Wilson Barker R N R in the garden at Oswalds.

107

Conrad in Corsica in 1921.

partly in France to escape heavy taxation. In 1920 he began what was to be his last work, *Suspense*, a Napoleonic novel, and in January 1921, went with Jessie to Corsica, staying in Ajaccio, where he did some background reading for the novel. But Corsica was 'Cold. Wet. Horrors.' In December, he was writing a short story which grew to be his last completed novel, *The Rover*, published in 1923.

He was now one of the most famous living authors in Britain and the United States and in 1923 made his only visit to America. He sailed to New York in the *Tuscania*, Captain Bone commanding.

Conrad's sketch of Peyrol, hero of *The Rover*, on an
envelope addressed to Conrad at Capel House.

Caricature of Conrad by Quiz from the *Saturday Review*,
4 October 1922.

Conrad on board the 'Tuscania', etching by Sir David Muirhead Bone, done on board in 1923.

(*Right*) Conrad, accompanied by Captain Bone, son of Sir David, arriving on the *Tuscania* at New York, at the beginning of his visit to America in 1923.

Christopher Morley tells us how Bone wrote in Morley's copy of *The Mirror of the Sea* in a formal shipmaster's manifest: 'Duly delivered at New York in good order and condition, Captain Joseph Conrad. David Wm. Bone, Master, R M S *Tuscania*, May Day 1923.' Conrad wrote to his wife: 'I will not attempt to describe to you my landing, because it is indescribable. To be aimed at by forty cameras held by forty men that look as if they came in droves is a nerve-shattering experience . . . I went along like a man in a dream and took refuge in Doubleday's car.'

He refused to lecture, but gave a talk at the house of a fashionable hostess, Mrs Curtiss James: 'I began at 9.45 and ended exactly at 11. There was a most attentive silence, some laughs and at the end, when I read the chapter of Lena's death, audible snuffling. . . . It was a great experience.' That is how Conrad saw the event of his lecture. Eleanor Palffy was at the lecture and she recorded:

Under the glare of electric lights hanging from the chandelier . . . a man with a beard stood on the raised dais. He had the hunted look of a hare about to be strangled by a poacher. His breath came in gasps, his voice shook. Little by little the ballroom . . . slipped away. The mist of sea-blue horizons blotted out. . . . The halting voice took on the power and assurance of its vision. . . . An hour passed. And then another thirty minutes. . . . A few tired business men had slipped out on the points of their toes to lean in the stone doorways, muttering something about getting a cigarette, but they did not quite leave the ballroom. After all, this was the greatest writer of the English language. . . . What a pity, though, that his pronunciation was so bad. . . . Good came out ringingly as 'gut', and blood as 'blut', which fitted in curiously with the complex beauties of his phrases. . . . He had been talking now for nearly two

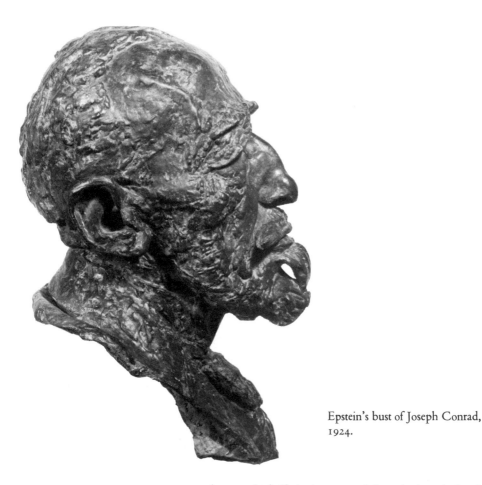

Epstein's bust of Joseph Conrad,
1924.

hours and a half. And so on until the end where the heroine Lena dies: capturing
the very sting of death Conrad's voice broke. . . . He was moved to sudden tears.
Conrad and all who had followed him there, drunk on Conrad.

But he was greeted on his return home with the news of Borys' secret
marriage. His response was, 'I don't want to know anything more
about it. It is done, and I have been treated like a blamed fool, damn.'
However, Borys Conrad recalls that 'Characteristically, he uttered
no reproaches when we met . . . and he greeted my wife with his
usual elaborate courtesy, putting her at ease immediately . . . Mrs C.
also ran true to form but . . . it was several years after J.C.'s death
before our relationship became again normal. Her rigid self-control
and composure had, I believe, been strengthened throughout the
years of her painful disability. . . .'

In November 1923, John Quinn sold his collection of Conrad
manuscripts which he had been collecting for many years. He had
bought them when Conrad was little read, but he was now a re-
nowned author, and Conrad reckoned that Quinn made 1,000 per

cent profit. The manuscript of *Victory* brought $8,000. Conrad muttered that 'he hadn't got his share of the plunder'.

The remaining months of his life were taken up with sickness on his part and on Jessie's. He still worked on *Suspense*, and he was also sitting to Epstein for a bust. Epstein wrote: 'He was crippled with rheumatism, crotchety, nervous, and ill. He said to me, "I am finished." There was pathos in his pulling out of a drawer his last manuscript to show me that he was still at work. There was no triumph in his manner, however, and he said that he did not know whether he would ever finish it. "I am played out," he said, "played out."' In May he declined the offer of a knighthood from Ramsay Mac-Donald, probably feeling it was inappropriate for an artist to accept such honours. A small irony here. According to Morley, 'the offer of a

Conrad in the garden at Oswalds, June 1924, shortly before his death.

knighthood was sent Conrad in an alarmingly official envelope. It lay long unopened on his desk, so long that the Prime Minister was gravely embarrassed and had to send a personal messenger to investigate. Conrad had thought it was the income tax.'

In July he suffered a heart attack, and wrote to Ernest Dowson, 'I begin to feel like a cornered rat.' Edward Garnett recalls his last meeting with Conrad: 'something moved me as we said good night, to put his hand to my lips. He then embraced me with a long and silent pressure. The next morning as we stood talking in his study, when the car was announced, he suddenly snatched from a shelf overhead a copy of the Polish translation of *Almayer's Folly*, wrote an inscription in it and pressed it into my hands. When I looked I saw that the date he had written in it was the date of our first meeting, thirty years back.' Curle visited him and on Saturday 2 August 1924 discussed *Suspense* with him: 'My mind,' said Conrad, 'seems clearer than it has done for months and I shall soon get hold of my work again.' Later that morning, they drove out to look at a house he was thinking of taking, but he suffered another heart attack and returned home. In the evening, Borys and John called on him. Jessie was in bed in the next room, only just back from the nursing home. 'Good night, Boy,' he said to Borys. 'You know I am really ill this time.'

Early next morning, he called to his wife, 'You Jess, I am better this morning. I can always get a rise out of you.' At eight-thirty he slid to the floor from his chair. He was dead. He was buried in Canterbury on 7 August 1924.

Conrad is one of the strangest figures in English literature – a Pole in English dress, first a sailor then earning a mighty reputation as a writer in a tongue not his own. He published his first novel in 1895, but did not have popular success until 1913 – and thus could only be said to be known as a celebrity in this country for a decade before he died. Moreover, he remained a mysterious figure all his life, who had lived in many of the obscure corners of the earth, and who was him-self, a supreme example of a touching destiny. In a review of *Suspense*, *Country Life* refers to the sketch made of Conrad on the *Tuscania*: 'A little, elderly, ailing man sits, half huddled, in an armchair . . . even in these days there have been giants on the earth. . . . That such a man should be dead: that such a man should have lived.'

His last written words are strangely prophetic. *Suspense*, published posthumously, is a huge unfinished fragment of a novel. Conrad laid down his pen after writing these words about the death of an old boatman who had died of exposure during the night:

'We have thrown a bit of canvas over him. Yes, that is the old man whose last bit of work was to steer a boat. . . .'

'Where is his star now?' said Cosmo, after looking down in silence for a time.

'Signore, it should be out,' said Attilio with studied intonation. 'But who will miss it out of the sky?'

For those of us who, throughout Conrad's writing life and since his day, have been 'drunk on Conrad', his star is not out yet.

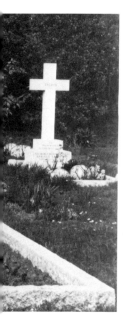

Conrad's grave at Canterbury.

CHRONOLOGY

1856 8 May: Apollo Korzeniowski and Eva Bobrowska marry in Oratov.

1857 3 December: birth of their only child, Józef Teodor Konrad Korzeniowski, at Berdyczów in Podolia, Poland.

1861 Family in Warsaw. 21 October: Apollo arrested and imprisoned for political activities.

1862 The family goes into exile in Vologda, northern Russia.

1863 The family allowed to move to Chernikhov.

1865 18 April: Death of Eva.

1866 Conrad spends summer with the family of his uncle, Thaddeus Bobrowski, at Nowofastów.

1868 January: Apollo and Conrad move to Lvov. Conrad begins writing plays.

1869 February: Apollo moves to Cracow and Conrad sent to school. 23 May: death of Apollo. Thaddeus Bobrowski becomes responsible for Conrad's welfare. Conrad attends a gymnasium in Cracow.

1872 Conrad begins to wish to go to sea.

1873 May: Conrad travels with his tutor to Switzerland. September: sent to school in Lvov.

1874 Thaddeus agrees that Conrad should join French merchant marine. First voyage, as passenger, on the sailing ship *Mont Blanc*.

1875 25 June: sails as apprentice on the *Mont Blanc* for the West Indies.

1876 8 July: sails as a steward on the *Saint-Antoine* for the West Indies. The first mate is Dominic Cervoni.

1877 Conrad misses a world voyage on the *Saint-Antoine* because of irregularities in his papers. Gets into debt.

1878 February: Conrad attempts suicide. 18 June: arrives at Lowestoft to enter British Merchant Navy. 11 July: joins the coaster *Skimmer of the Seas*. October: joins the wool-clipper *Duke of Sutherland*, bound for Australia, as ordinary seaman.

1879 Joins the steamship *Europa* for a Mediterranean trip.

1880 June: passes his examination as second mate. 21 August: embarks as an officer on the clipper *Loch Etive*, bound for Sydney.

1881 21 September: sails as second mate on the steamship *Palestine* for the Far East. December: she puts back into Falmouth for repairs.

1882 September: *Palestine* sails.

1883 March: her cargo of coal catches fire and ship abandoned off Sumatra. April: Court of Inquiry into loss of *Palestine* held in Singapore. July: Conrad holidays with Thaddeus Bobrowski in Marienbad and Töplitz. 10 September: sails as second mate on the sailing ship *Riversdale*, bound for the East.

1884 28 April: leaves Bombay for England in the *Narcissus*. December: passes his first mate's examination.

1885 24 April: embarks at Hull as second mate on the *Tilkhurst*, a sailing ship bound for Singapore. Considers giving up the sea.

1886 19 August: becomes a naturalized British subject. Passes examination for a master's certificate. During this period, he appears to have written his first short story, *The Black Mate*.

1887 16 February: joins the sailing ship *Highland Forest*, bound for Samarang, as first mate. Leaves the ship at Samarang and goes into hospital in Singapore. Signs as mate on the steamship *Vidar*. Meets originals of Almayer and Tom Lingard, etc.

1888 19 January: appointed master of the barque *Otago*, then at Bangkok. Takes *Otago* to Singapore, Sydney and Mauritius.

1889 Returns to England in early summer. Begins writing *Almayer's Folly*. Works for Barr, Moering and Co. Early November: interviewed in Brussels by Captain Albert Thys of the Société Anonyme Belge pour le Commerce du Haut-Congo.

1890 February: visits Brussels and meets Marguerite Poradowska. Reaches his uncle's estate in Poland. Is appointed captain of river steamer on the Congo. Arrives Congo 12 June.

1891 January: returns, sick, to England, visits Brussels, goes into hospital in London. Convalesces at Champel near Geneva. August: works again for Barr, Moering and Co. November: sails as first mate in the clipper *Torrens* for Australia.

1892 On return voyage meets John Galsworthy and Edward Sanderson.

1893 6 December: goes to Rouen to take post of first officer on the *Adowa*.

1894 Voyage of *Adowa* cancelled. February: death of Thaddeus Bobrowski. 4 October: *Almayer's Folly* accepted for publication by Fisher Unwin. Conrad meets Edward Garnett. November: meets Miss Jessie George.

1895 April: *Almayer's Folly* published.

1896 24 March: marries Jessie George. Goes to Brittany. *An Outcast of the Islands* published.

1897 March: moves to Ivy Walls. Meets Cunninghame Graham and Stephen Crane. *The Nigger of the 'Narcissus'* published. Relationship with *Blackwood's Magazine* begins.

1898 *Tales of Unrest* published. Birth of first son, Borys. Meets Ford Madox Ford. Moves to Pent Farm. Meets James Wells. Collaboration with Ford.

1900 *Lord Jim* published.

1901 *The Inheritors* (with Ford) published.

1902 *Youth* volume published.

1903 *Typhoon* volume and *Romance* (with Ford) published. J.B. Pinker is now Conrad's agent.

1904 Jessie injures knees in a fall. Conrad's bankers fail. *Nostromo* published.

1905 Trip to Europe. *One Day More* performed.

1906 *The Mirror of the Sea* published. 2 August: second son, John, born. Trip to Europe.

1907 *The Secret Agent* published. Moves to Someries, Bedfordshire.

1908 *A Set of Six* published.

1909 Moves to Aldington, Kent.

1910 Quarrels with Pinker. Has nervous breakdown. June: moves to Capel House.

1911 Granted Civil List Pension. Sells manuscripts to Quinn. *Under Western Eyes* published.

1912 *'Twixt Land and Sea* and *A Personal Record* published. Meets Richard Curle.

1913 Success of *Chance* in America and England. Meets Bertrand Russell.

1914 Visit to Poland.

1915 *Victory* and *Within the Tides* published.

1917 *The Shadow-Line* published.

1919 Moves to Oswalds. Begins dramatization of *The Secret Agent*. *The Arrow of Gold* published.

1920 Dramatization of *Because of the Dollars*. *The Rescue* published.

1921 Trip to Corsica. *Notes on Life and Letters* published.

1922 Death of Pinker.

1923 April/June: visit to America. Borys marries. Manuscripts resold. November: *The Rover* published.

1924 Sits for Epstein bust. Declines knighthood. July: has heart attack. 3 August: dies; and, 7 August, buried at Canterbury. *The Nature of a Crime* (with Ford) published.

1925 *Tales of Hearsay* and *Suspense* published.

1926 *Last Essays* published.

LIST OF ILLUSTRATIONS

Matter between square brackets indicates the sources of quotations used in the captions; unless otherwise stated, these quotations come from Conrad's own writings.

Frontispiece: Joseph Conrad. Photo Radio Times Hulton Picture Library.

5 Apollo Nałęcz Korzeniowski, Conrad's father. Jagiellońian Library, Cracow. Photo Jan E. Sajdera. [Letter to E. Garnett, 20 January 1900]

Eva Korzeniowska, Conrad's mother. Photo J.M. Dent. [Author's Note to *A Personal Record*]

7 Conrad's birthplace, Derebczynka Manor, near Berdyczów, in the Ukraine. Photo courtesy Borys Conrad.

Conrad as a boy in Warsaw, 1862. Photo Mansell Collection.

8 Patriotic Cross. A souvenir from the time of the 1861 uprising. Historical Museum, Warsaw.

Warsaw. The Royal Castle, *c.* 1870. Photo CAF Warsaw.

9 Warsaw. Nowy Świat Street. Photo Danuta B. Lomaczewska, courtesy Andrzej Braun.

10 Warsaw. Courtyard of the jail. Photo Danuta B. Lomaczewska,

courtesy Andrzej Braun. [Letter to Kazimierz Waliszewski, 5 December 1903]

11 Vologda, Poland. Photo Danuta B. Lomaczewska, courtesy Andrzej Braun. [*A Personal Record*]

12 Lvov. No. 5 Szeroka Street II. Photo Danuta B. Lomaczewska, courtesy Andrzej Braun.

Lvov. Photo courtesy the Polish Library, London.

13 Cracow. Historical Museum, Warsaw. [*Notes on Life and Letters*, 'Poland Revisited']

Cracow. No. 12 Poselska Street, where Apollo Korzeniowski died. Photo Danuta B. Lomaczewska, courtesy Andrzej Braun.

14 Cracow. North-east corner of St Mary's Church. Jagiellońian Library, Cracow. [*Notes on Life and Letters*, 'Poland Revisited']

15 Grave of Apollo Korzeniowski in the Rakowicki Cemetery, Cracow. Photo Danuta B. Lomaczewska, courtesy Andrzej Braun.

16 Thaddeus Bobrowski, Conrad's uncle. Jagiellońian Library, Cracow. Photo Jan E. Sajdera. [Letter to Kazimierz Waliszewski, 5 December 1903]

Conrad in 1873. From a photo taken shortly before he went to

sea. Photo J. M. Dent. [*A Personal Record*]

17 Cracow. No. 43 Florian Street (second from left), the boarding house where Conrad lived between 1869 and 1870. Photo Danuta B. Lomaczewska, courtesy Andrzej Braun. [*Notes on Life and Letters*, 'Poland Revisited']

18 Marseilles. The Old Port, 1898. Photo Mansell Collection.

20 C. Delestang's certificate of discharge of Conrad's service on the *Mont Blanc*, Marseilles, 26 April 1880. The Beinecke Rare Book and Manuscript Library, Yale University.

21 Marseilles. Promenade du Prado. Photo courtesy A. van Marle. [*A Personal Record*]

22 Cesar Cervoni. Photo courtesy the author.

23 Marseilles. View of the Rue Cannebière and the Old Port. Photo Mansell Collection. [*The Arrow of Gold*]

25 Monte Carlo. Gaming rooms, 1890. Photo Mansell Collection.

26 Lowestoft. The harbour, *c.* 1890. National Maritime Museum, London.

27 Newcastle upon Tyne, 1887. From the *Illustrated London News*, showing the Swing Bridge, opened 1876. Photo Newcastle upon Tyne Libraries.

28 Conrad aged twenty-eight. Photo courtesy Borys Conrad.

29 Sydney. George Street, *c.* 1880. Royal Commonwealth Institute, London.

The *Duke of Sutherland*, possibly in Sydney Harbour. Photo courtesy Borys Conrad. [*The Mirror of the Sea*]

30 The Pool of London, *c.* 1885. National Maritime Museum, London. [*The Mirror of the Sea*]

31 Conrad's master's certificate, 1886. The Beinecke Rare Book and Manuscript Library, Yale University.

32 The *Loch Etive* at Melbourne. National Maritime Museum, London.

33 A. P. Krieger and his wife. Photo courtesy Mrs B. Ogilvie.

Sydney. The Circular Quay, *c.* 1880. Royal Commonwealth Institute, London. [*The Mirror of the Sea*]

34 Crew List of the *Palestine*. Public Record Office, London.

35 Muntok. General view from Bangka Strait. Photo courtesy Andrzej Braun.

36 Conrad at Marienbad in 1883.

Captain Beard's report on Conrad, about the *Palestine*.

37 Conrad's certificate of discharge from the *Riversdale*, 1884. The Beinecke Rare Book and Manuscript Library, Yale University.

38 Bombay, *c.* 1885. Royal Commonwealth Society, London.

39 The *Tilkhurst* at San Francisco. Photo courtesy Borys Conrad.

40 Entrance of the Winter Garden of the Krasnapolsky café, Amsterdam; engraving by E. and A.

Tilley after the watercolour by Chr. Rochussen and P. A. Schipperus. From *Eigen Haard*, 1884. British Museum. Photo Fleming. [*The Mirror of the Sea*]

41 Java. Heerenstraat, Samarang, *c.* 1890. Royal Commonwealth Society, London.

42 Singapore. Street scene, *c.* 1890. Royal Commonwealth Society, London. [*The End of the Tether*]

Singapore. Boat Quay, *c.* 1890. Royal Commonwealth Society, London. [*The Rescue*]

43 Singapore. Dock, *c.* 1890. Royal Commonwealth Society, London.

44 Augustus Podmore Williams, first mate of the *Jeddah*, with his wife in Singapore, 1883. Photo courtesy the author. [*Lord Jim*]

Augustus Podmore Williams, first mate of the *Jeddah*, as a young seaman at his father's rectory, 1868. Photo courtesy the author. [*Lord Jim*]

45 Tandjong Redeb. Photo Australian Intelligence.

46 Charles Olmeijer. Photo courtesy A. van Marle.

Olmeijer's grave, Surabaya. Photo courtesy the author.

Malay house, *c.* 1880. Royal Commonwealth Society, London. Photo Freeman.

47 Jim Lingard as a young man. Photo courtesy the author.

Captain William Lingard ('Rajah Laut'). Photo Lambert & Co., Singapore, courtesy A. van Marle.

48 Letter from Captain John Snadden to his family. Photo courtesy the author.

John Snadden, former master of the *Otago*. Photo courtesy the author.

49 The *Otago*; anonymous painting.

50 Bangkok. Canal, *c.* 1890. Royal Commonwealth Society, London.

53 Captain Albert Thys, 1892. Musée Royal de l'Afrique Centrale, Tervuren.

54 Sir Henry Morton Stanley. Photo Radio Times Hulton Picture Library.

Marguerite Poradowska, Conrad's 'aunt'. Photo by Klary of Brussels, which appeared in *Revue Encyclopédique* for 1896. Photo Harvard University Library.

55 Thaddeus Bobrowski, *c.* 1890. Photo courtesy Borys Conrad.

The first page of Thaddeus Bobrowski's 'Document'. Jagiellonian Library, Cracow. Photo Jan E. Sajdera.

56 Conrad. Photo taken before his starting for the Congo, 1890.

Captain Freiesleben. Photo Moller, Copenhagen. Courtesy A. van Marle. [*Heart of Darkness*]

57 Roger Casement in the Congo. National Library of Ireland, Dublin.

58 Camille Delcommune, 1892, manager of the Kinchassa station, the Congo. Photo courtesy the author. [*Heart of Darkness*]

Alexandre Delcommune with hippo heads. Photo courtesy the author. [*Heart of Darkness*]

59 The *Roi des Belges*, a Congo steamer. Photo courtesy the author. [*Heart of Darkness*]

Port of Leopoldville, in 1887, including the *A.I.A.* and *Ville de Bruxelles*. Musée Royal de l'Afrique Centrale, Tervuren.

60 Stanley Falls, 1896. Photo courtesy the author.

Buying ivory in the North Congo, showing a Dutch trader at Bumangi, *c.* 1890. Photo courtesy the author. [*Heart of Darkness*]

61 Building the railway at Matadi, the Congo, *c.* 1890. Photo courtesy the author. [*Heart of Darkness*]

62 Georges Antoine Klein's grave. Photo courtesy the author.

Captain Duhst (*left*) at Matadi, 8 November 1890. Photo courtesy the author.

63 Geneva. Promenade des Bastions, *c.* 1890. Bibliothèque Publique et Universitaire, Geneva. Photo Nicolas Bouvier. [*Under Western Eyes*]

64 The *Torrens*. National Maritime Museum, London. ['The *Torrens*: A Personal Tribute']

The *Torrens*. National Maritime Museum, London.

65 John Galsworthy and Edward Sanderson on board the *Torrens*, 1893. Photo Ian Sanderson. [Galsworthy, Letter of 23 April 1893]

Photo of Conrad inscribed by him to the Sandersons, 1913. Photo Ian Sanderson.

66 The main deck of a large sailing-vessel, *c.* 1890. Peabody Museum, Salem, Mass. [*The Nigger of the 'Narcissus'*]

67 Seamen furling sail on a barque, *c.* 1890. [*The Nigger of the 'Narcissus'*]

69 Edward Garnett with his son, David Garnett, 1897. Photo courtesy David Garnett.

70 Conrad and H. G. Wells. Photo Frank Wells.

71 Jessie Conrad at the time of her marriage, 1896. Photo courtesy Borys Conrad.

Conrad's marriage certificate. General Register Office, Somerset House, London.

73 Letter to Edward Garnett, dated 9 April 1896, from Île-Grande, Lannion, Brittany. Photo courtesy the author.

74 Ivy Walls, in Essex, where the Conrads lived from March 1897 to October 1898. Photo J. M. Dent.

75 G. F. W. Hope. Photo courtesy the Hope family.

The yawl *Nellie*, R S Y C, owned by G. F. W. Hope, from a sketch by Hope. Photo courtesy the author.

William Blackwood. Photo courtesy, *Blackwood's Magazine*.

76 R.B. Cunninghame Graham, dressed as a gaucho, probably soon after his return from South America in the late 1870s. Photo courtesy Admiral Sir Angus Cunninghame Graham.

77 Photo of Conrad, inscribed to Cunninghame Graham, 1903. Photo courtesy Admiral Sir Angus Cunninghame Graham.

78 Stephen Crane, 1899.

Ford Madox Ford (Hueffer). Sketch by J. A. Hipkins *c.* 1896. Trustees of the National Library of Scotland, Edinburgh.

79 Pent Farm, near Hythe, where Conrad lived from 1897 to 1907. Photo courtesy Borys Conrad.

80 Henry James at Brede Place (the home of Stephen Crane), 1899. Photo Columbia University, New York.

81 H. G. Wells. Photo Frank Wells.

Rudyard Kipling, 1899, by P. Burne Jones. National Portrait Gallery, London.

82 Borys Conrad with his mother at Pent Farm, 1900. Photo courtesy Borys Conrad.

83 Jessie Conrad, 1926. The Beinecke Rare Book and Manuscript Library, Yale University.

84 Joseph Conrad with John Conrad and Jane Anderson Taylor, 1916. Photo courtesy Borys Conrad.

Joseph Conrad, Conrad Hope, Borys and Jessie Conrad on the first long motor trip to visit the Hopes. Photo courtesy Borys Conrad.

85 J.B. Pinker and Conrad at Pinker's home, 1922. Photo courtesy Borys Conrad.

86 Sir Henry John Newbolt. Medallion by T. Spicer-Simson, *c.* 1922. National Portrait Gallery, London.

Conrad, 1922. Photo T. Spicer-Simson. Photo Radio Times Hulton Picture Library.

87 The last page of the first draft of *Nostromo*, 30 August 1904.

88 Conrad's Letter to A.P. Krieger, 15 March 1904. Photo courtesy Mrs B. Ogilvie.

89 Helen Rossetti, an anarchist. Photo courtesy the author.

Martial Bourdin, the Greenwich anarchist. Photo courtesy the author.

The anarchist outrage at Greenwich, 15 February 1894. Scene of the explosion from the *Illustrated London News*. Photo Radio Times Hulton Picture Library.

90 John Conrad (*right*) with his frequent playmate, Robin Douglas, son of Norman Douglas *c.* 1913. Photo courtesy Borys Conrad.

91 Borys Conrad with Edmund Oliver and Joseph Conrad on

joining HMS *Worcester*, 1911. Photo courtesy Borys Conrad.

Someries (Bedfordshire), with Conrad's dog, Escamillo, in the foreground, 1908. Photo courtesy Borys Conrad.

92 Capel House, near Ashford, Kent, to which the Conrads moved in 1910. Photo courtesy Borys Conrad.

The study at Capel House, with Conrad's easy chair and writing table. Francis Warrington Dawson I and II papers, Perkins Library, Duke University, Durham, N. Carolina.

93 Jessie and Borys Conrad, Miss Glasgow and Conrad in the garden at Capel House, 1914. Francis Warrington Dawson I and II papers, Perkins Library, Duke University, Durham, N. Carolina.

Joseph Conrad with Jessie and John in the study at Capel House, 1915. Photo courtesy Borys Conrad.

96 Conrad in 1904. Photo by Beresford. Photo Radio Times Hulton Picture Library.

98 Conrad's proof-sheet of *A Personal Record*, p. 66.

99 Note in Richard Curle's copy of *Almayer's Folly*.

100 The Górka Narodowa estate (property of Stefan Buszczyński), near Cracow, where Conrad visited, 1914. Photo Danuta B. Lomaczewska, courtesy Andrzej Braun.

101 Cracow. The Hotel Pod Róza where Conrad stayed in 1914. Photo Danuta B. Lomaczewska, courtesy Andrzej Braun.

102 Portrait of Conrad signed 'K. Gorski, Zakopané', executed 23 August 1914. Photo courtesy Borys Conrad.

103 Zakopané. Jagiellonska Street, showing the bungalow of A. Zagórska, where Conrad stayed with his family in 1914. Photo Danuta B. Lomaczewska, courtesy Andrzej Braun.

John Conrad at Zakopané, 1914.

Borys Conrad and his mother in 1914.

104 Inscribed photo of Conrad on HMS *Ready*, 1916. The Beinecke Rare Book and Manuscript Library, Yale University.

105 Conrad in later life. Photo Mansell Collection.

106 Oswalds, Bishopsbourne, near Canterbury, where the Conrads moved, 1919. Photo courtesy Borys Conrad.

Conrad on the window-ledge of the study at Oswalds, with Carola and Angela Zagórska, c. 1921–22. Photo courtesy Borys Conrad.

107 Conrad with Sir David Wilson Barker, RNR, in the garden at Oswalds. Photo courtesy Borys Conrad.

108 Conrad in Corsica, 1921. Photo courtesy the author.

109 Conrad's sketch of Peyrol from *The Rover* on an envelope address-

ed to Conrad at Capel. The Beinecke Rare Book and Manuscript Library, Yale University.

Caricature of Conrad by Quiz from the *Saturday Review*, 4 October 1922.

110 *Conrad on board the 'Tuscania'*; etching by Sir David Muirhead Bone, executed during the voyage. Photo Craddock and Barnard, London.

111 Conrad arriving at New York, accompanied by Captain Bone, on the *Tuscania*. Photo courtesy Borys Conrad.

112 Epstein bust of Joseph Conrad for which he sat in 1924. National Portrait Gallery, London.

113 Conrad in the garden at Oswalds, June 1924.

114 Conrad's grave at Canterbury. The Beinecke Rare Book and Manuscript Library, Yale University.

SELECT BIBLIOGRAPHY

WORKS BY JOSEPH CONRAD

Almayer's Folly 1895
An Outcast of the Islands 1896
A Personal Record 1912
A Set of Six 1908. 'The Brute',
 'Gaspar Ruiz', 'An Anarchist',
 'The Informer', 'The Duel', 'Il
 Conde'
Chance: A Tale in Two Parts 1913
Last Essays 1926
Lord Jim: A Tale 1900
Nostromo: A Tale of the Seaboard 1904
Notes on Life and Letters 1921
Suspense: A Napoleonic Novel 1925
Tales of Hearsay 1925. 'Prince
 Roman', 'The Warrior's Soul',
 'The Tale', 'The Black Mate'
Tales of Unrest 1898. 'The Idiots', 'An
 Outpost of Progress', 'The Lagoon',
 'The Return', 'Karain, a Memory'
*The Arrow of Gold: A Story between
 Two Notes* 1919
*The Mirror of the Sea: Memories and
 Impressions* 1906
*The Nigger of the 'Narcissus': A Tale
 of the Sea* 1897
*The Rescue: A Romance of the
 Shallows* 1920
The Rover 1923
The Secret Agent: A Simple Tale 1907
The Shadow-Line: A Confession 1917
'Twixt Land and Sea: Tales 1912.
 'The Secret Sharer', 'A Smile of
 Fortune', 'Freya of the Seven Isles'
Typhoon, and Other Stories 1903.
 'Typhoon', 'Falk', 'Amy Foster',
 'Tomorrow'
Under Western Eyes 1911
Victory: An Island Tale 1915
Within the Tides: Tales 1915. 'The
 Partner', 'The Inn of the Two
 Witches', 'Because of the Dollars',
 'The Planter of Malata'
*Youth: A Narrative; and Two Other
 Stories* 1902. 'Youth', 'Heart of
 Darkness', 'The End of the Tether'

WITH FORD MADOX FORD

Romance: A Novel 1903
The Inheritors: An Extravagant Story
 1901
The Nature of a Crime 1924

LETTERS AND BIOGRAPHIES

Baines, Jocelyn *Joseph Conrad. A
 Critical Biography* 1960
Blackburn, William (ed.) *Joseph
 Conrad: Letters to William
 Blackwood and David S. Meldrum* 1958
Conrad, Borys *My Father: Joseph
 Conrad* 1970
Conrad, Jessie *Joseph Conrad and his
 Circle* 1935
Conrad, Jessie *Joseph Conrad as I
 knew him* 1926
Curle, Richard (ed.) *Conrad to a
 Friend: 150 Selected Letters from
 Joseph Conrad to Richard Curle* 1928
Curle, Richard *Joseph Conrad: a
 study* 1914
Ford, Ford Madox *Joseph Conrad: a
 personal remembrance* 1924
Garnett, Edward (ed.) *Letters from
 Joseph Conrad, 1895–1924* 1928
Gee, J. A. and Sturm, P. J. (eds.)
 *Letters of Joseph Conrad to Marguerite
 Poradowska, 1890–1920* 1940
Gordan, John Dozier *Joseph Conrad,
 the making of a novelist* 1940
Jean-Aubry, G. *Joseph Conrad: Life
 and Letters* (2 vols), 1927
Jean-Aubry, G. *The Sea Dreamer: a
 definitive biography* 1957
Meyer, Bernard C. *Joseph Conrad,
 a psychoanalytic biography* 1967
Najder, Zdzisław (ed.) *Conrad's
 Polish Background: letters to and from
 Polish friends* 1964
Sherry, Norman *Conrad's Eastern
 World* 1966
Sherry, Norman *Conrad's Western
 World* 1971
Watts, C. T. (ed.) *Joseph Conrad's
 Letters to R. B. Cunninghame
 Graham* 1969

INDEX